Arakawa and Madeline H. Gins

THE MECHANISM OF MEANING

Work in progress (1963–1971, 1978). Based on the method of

ARAKAWA

Harry N. Abrams, Inc., Publishers, New York

Editor: Ellen Schwartz
Designer: Nai Y. Chang

Library of Congress Catalogue Card Number: 78-24664
International Standard Book Number: 0-8109-0667-8 (H.C.)
0-8109-2165-0 (pb.)

Printed and bound in Japan

THE MECHANISM OF MEANING (NO. 2)

PREFACE

If we had not been so desperate at that time, we might not have chosen such an ambitious title for this work. Yet what else would we have called it? After all, the phenomena we were studying were not simply images, percepts, or thoughts alone. Our subject is more nearly all given conditions brought together in one place.

Death is old-fashioned. We had come to think this way, strangely enough. Essentially, the human condition remains prehistoric as long as such a change from the Given, a distinction as fundamental as this, has not yet been firmly established.

If thought were meant to accomplish anything, surely it was meant to do this. Yet why had history been so slow? Was there something wrong with the way the problem was being pictured? What if thinking had been vitiated by having become lost in thought, for example? What is emitted point-blank at a moment of thought, anyway? Let's take a second look at these comic figures, we decided. There did not yet exist even the most rudimentary compendium of what takes place or of the elements involved when anything is "thought through." Why not picture some of these moments ourselves, we thought, just a few?

As we proceeded, our forming intention took shape rather unevenly. Only some of the ambiguous events we examined made ordinary sense. There was also a natural tendency on our part as artist and poet to favor the nonsense. Although we certainly did not want to propose any theory, we did begin to notice some correspondence between each event and the rather awkward term "meaning."

The vagueness of the term was suitable. Meaning might be thought of as the desire to think something—anything—through; the will to make sense out of the ever-present fog of not-quite-knowing; the recognition of nonsense. As such it may be associated with any human faculty. Since each occurrence of meaning takes place primarily along one or another of these paths, we roughly derived our list of subdivisions from them. The list as a whole is not intended to be any less inconsistent, clumsy, or redundant than the original on which it was based, that is, the composite mechanism of meaning in daily living viewed point-blank from moment to moment.

We hope future generations find our humour useful for the models of thought and other escape routes that they shall construct!

Arakawa and M. H. Gins, New York, 1978

1 NEUTRALIZATION OF SUBJECTIVITY

USE THESE EXERCISES AS A SERIES OF 'FILTERS'
THROUGH WHICH TO PASS SUBJECTIVE MODES OF
INTERPRETATION AND NEUTRALIZE TO SOME DEGREE:

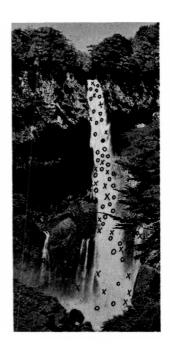

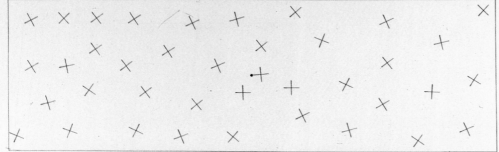

PLEASE THINK ONLY OF THE DOT NOT OF THE ✕'S.

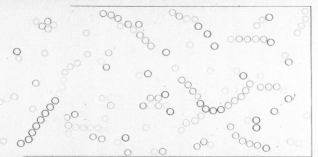

PLEASE THINK ONLY OF THE DOT NOT OF THE CIRCLES.

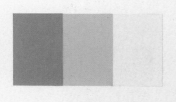

USING THE SAME SYSTEM SEPARATE
THE NEXT TWO SHADES

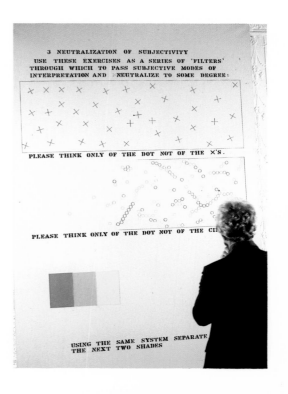

Although it is uncertain how non-sensical any or all meaning is or may turn out to be, probably there will never be a reader of this book dispossessed entirely of the mechanism of meaning.

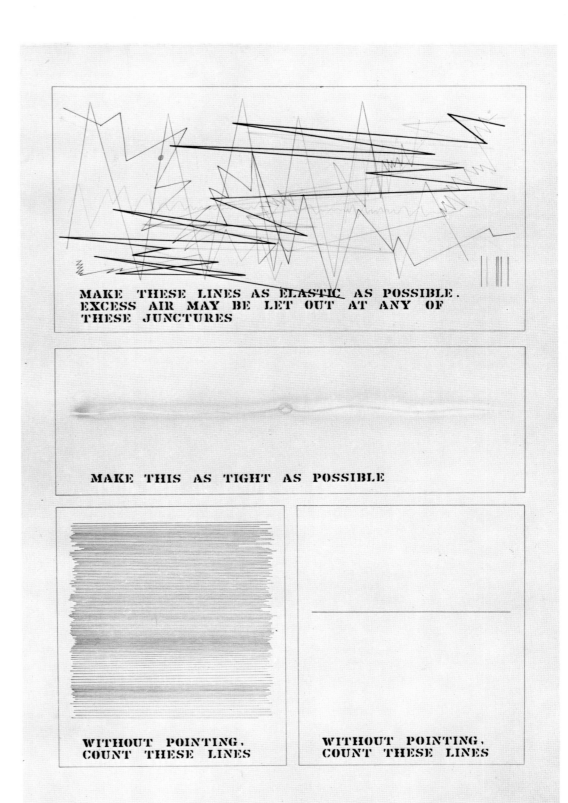

LOOK AT ANY CLOSE OBJECT AS YOU OPEN AND CLOSE YOUR EYES FOR SEVERAL MINUTES

As many $\left\{ \begin{array}{c} \text{movements} \\ \text{tissues} \end{array} \right\}$ as the following:

CHOOSE EVERYTHING

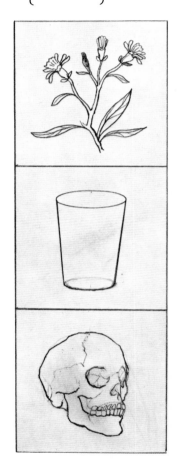

ON THE CANVAS

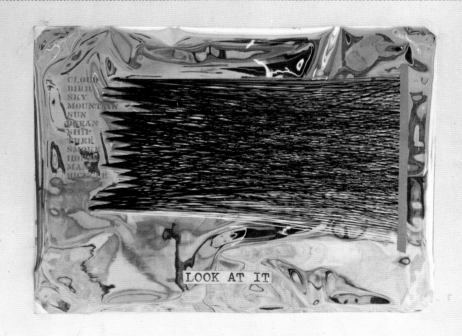

LOOK AT IT

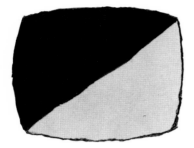

Turn left / as / you turn right

Thr e pro essors f ph l s phy a e se king
em loyment i a ce tain uni ersity. he Dea i for s
the a ollows: hall wa b ue r wh te ot o
e ch f y ur for hea s. f ou ee a hite ot
on an o e's f r ead, lease r ise our ig t ha d
A so n a ou kno our wn olo, p ease l w r
ou h d.'
He uts wh te d ts o ll th e pro ssors, a d
f ur se t ey a l aise t eir ands. Fa rl s no e
o th m, Pr fes or S l (Ip) Hop , lo ers is ha
a d de ares, 'O viou ly ust h ve a w it ot.'
'H w d ou kn ? sks t e D n.
Pro or H ph's ex anation w ns im t e j b.
H w oe ee pant at e ust h ve a w ed ?
(T e ea o irr rs nt r m)

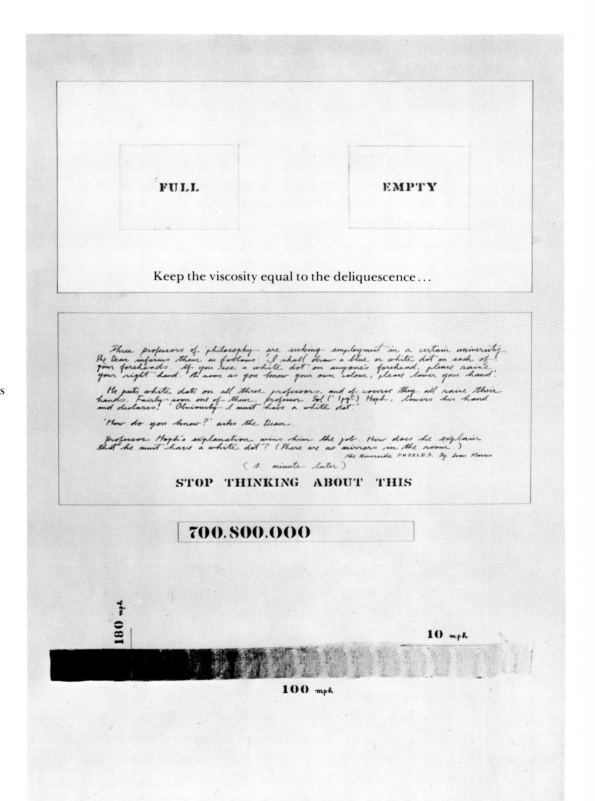

Neutralization

No. 1 For instance — scratch an object —

(to neutralize what?)

No. 2 For as long as possible keep one finger frozen
one extremely hot.

No. 3 Make large can of pure air spray
spray along the contours of any object.

(to begin with barely visible, then objects in human scale
then giants)

To what extent does size affect quality of neutralization —

No. 4 Some neutralizations

ice candle

Susannah neutralizes herself.
— in mirror
— leg in water
— touching her foot
— cloth between arm and leg
— angle of body
— being spread out on
different textures.
— dispersing her property
(comb, pearls, etc.)
— dividing hair into
many braids
— same bracelet on each arm
— listening.

20th-century thermometer

also, was TINTORETTO
his own daughter??

Each elder neutralizes himself
— by not seeing Susannah.
— the standing one by touching a tree (fence?)
— the other by grabbing a cloth and the losing of all his body
except for head and arm.
— they neutralize each other through the opposition of
the angle through which they see nothing?
In general
small ducks neutralize the large one
water neutralizes the mirror — itself dull through neutralization?
both animal and bird are looking away.
Besides this list there must be many more neutralizations in
operation in this painting.

17th-century thermometer

Blanket thermometer

(Waiting Texture)
Thermometresses

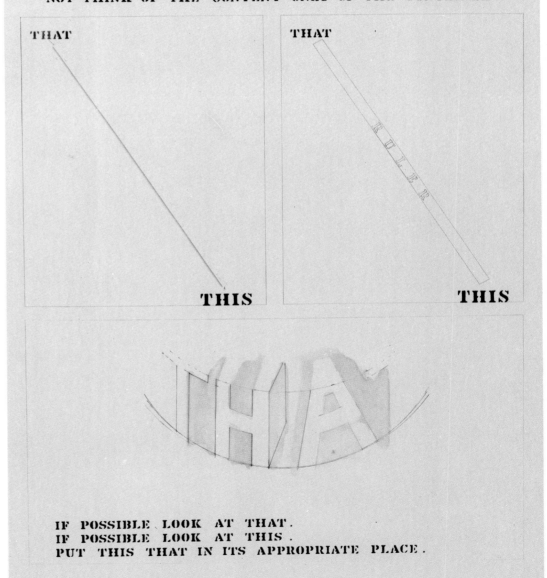

To become attached to and the
length of some attachments....

"FIVE MILES" MEANS
- **1. HEADACHE**
- **2. DELICIOUS**
- **3. COLOR**

4. 250 lbs.
5. Pascal
6. Ice Age

"CHAIRS" ARE
- **1.**
- **2. BIRTHDAYS**
- **3. MISS**
- **4.** ▭
- **5. MELODIES**

6

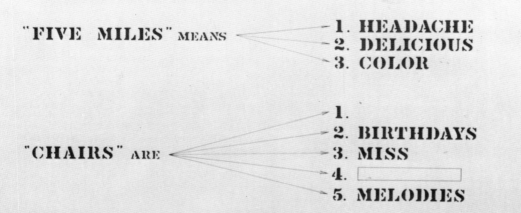

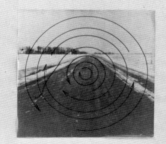

ENCLOSURE FOR ONE ATTENTION SPAN

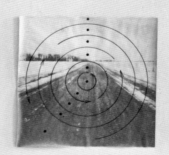

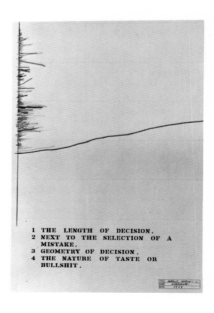

1 THE LENGTH OF DECISION.
2 NEXT TO THE SELECTION OF A MISTAKE.
3 GEOMETRY OF DECISION.
4 THE NATURE OF TASTE OR BULLSHIT.

THESE DOTS SHOULD APPROACH THE VIEWER AT REGULAR INTERVALS STARTING FROM THE MOST DISTANT BOUNDARY SUGGESTED BY THIS FIGURE

What is necessary to
maintain a blank?

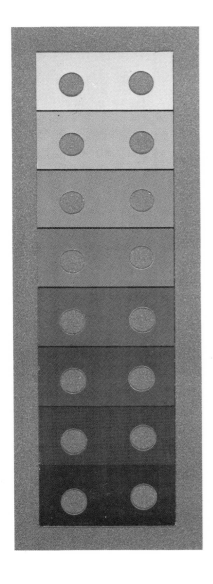

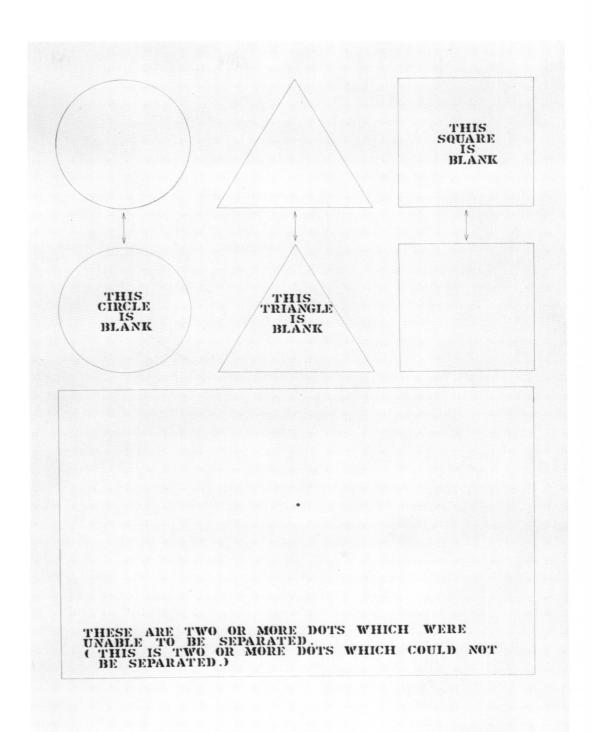

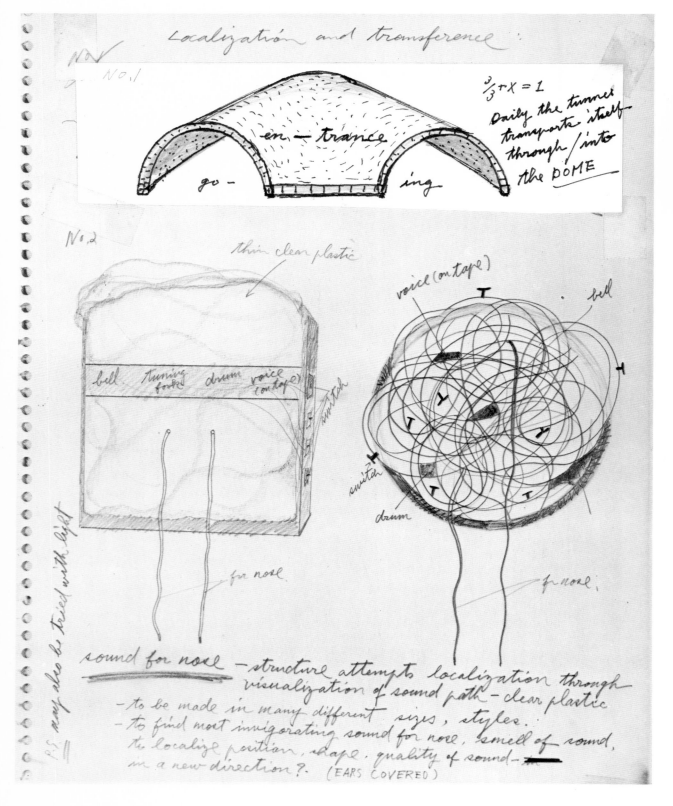

Localization and transference:

No. 1

$\frac{3}{3} + X = 1$

Daily the tunnel transports itself through / into the DOME

en — trance
go — ing

No. 2

thin clean plastic

bell | tuning forks | drum | voice (on tape)

switch

for nose

voice (on tape)

bell

switch

drum

for nose.

P.S. may also be tried with light

sound for nose — structure attempts localization through
visualization of sound path — clear plastic
— to be made in many different sizes, styles.
— to find most invigorating sound for nose, smell of sound,
 to localize position, shape, quality of sound —
 in a new direction? (EARS COVERED)

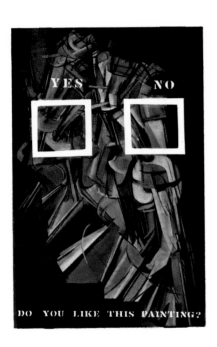

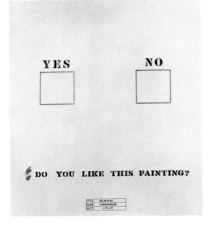

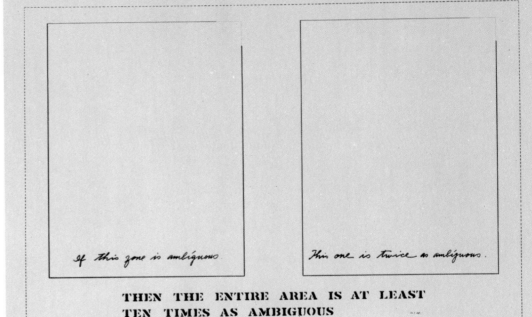

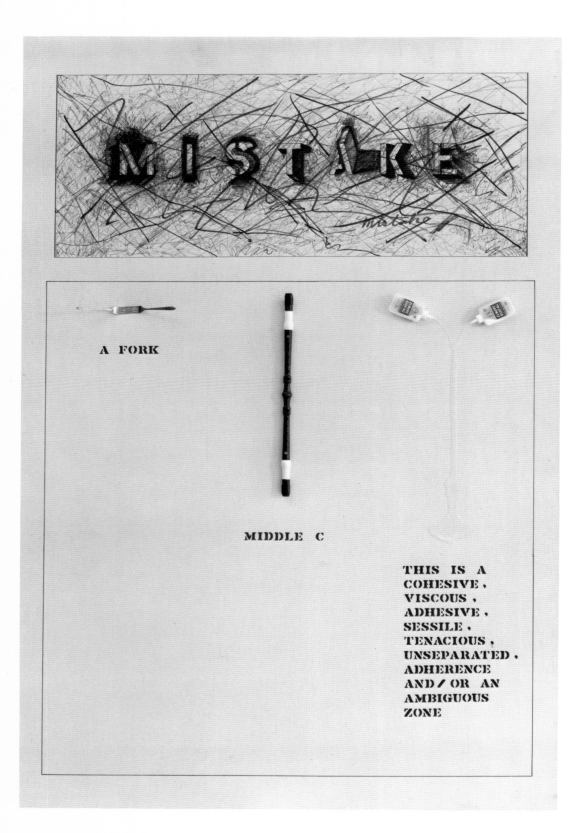

A FORK

MIDDLE C

THIS IS A
COHESIVE,
VISCOUS,
ADHESIVE,
SESSILE,
TENACIOUS,
UNSEPARATED,
ADHERENCE
AND/OR AN
AMBIGUOUS
ZONE

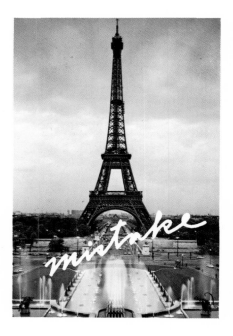

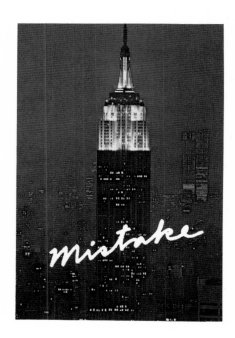

Reflected Voice

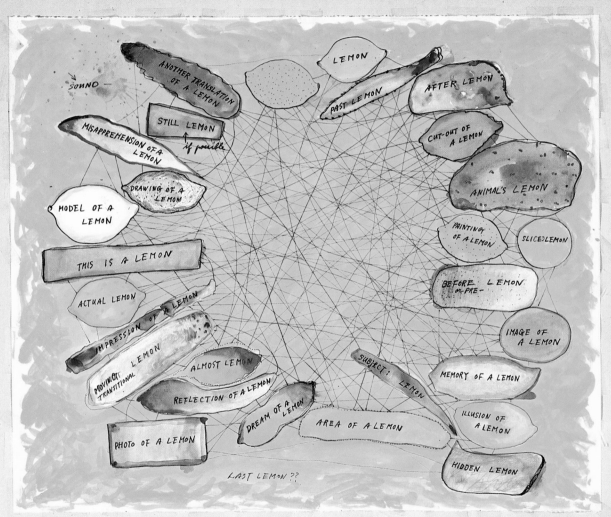

About the network of AMBIGUOUS ZONES OF A LEMON. *sketch no. 2*

To make a three-dimensional model of this - perhaps based on double helix if that one day exists, then the quality of ambiguity might change

Ambiguous zones exist within each statement or representation and across the conceptual distances which separate these.

How to estimate the extent of these zones?

How not to think in terms of estimation but to deal with ambiguous zones as basic units ?

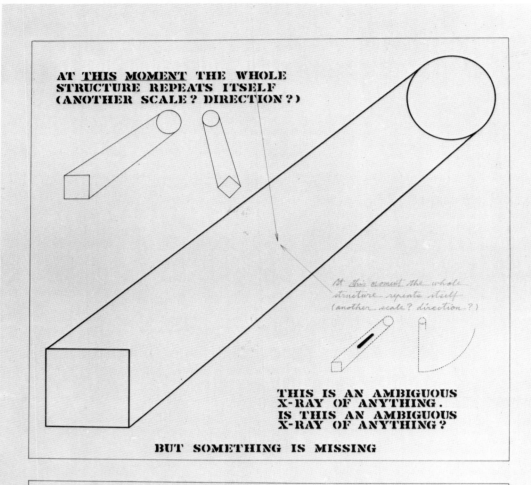

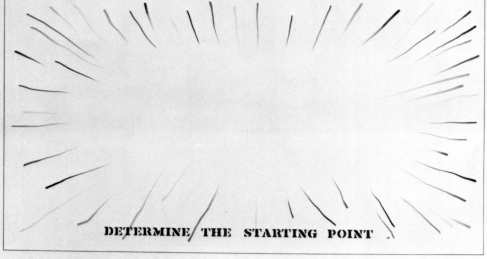

DETERMINE THE STARTING POINT

This is upside down.

Two blacks.

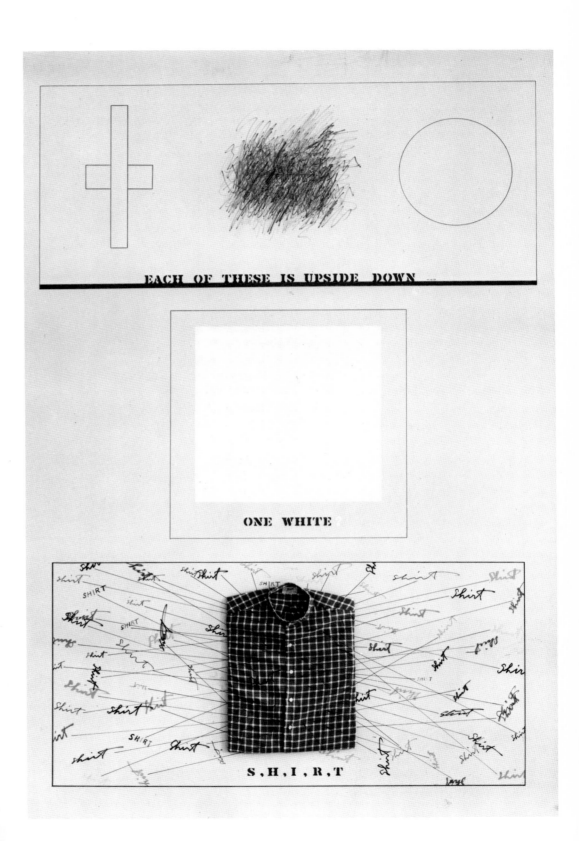

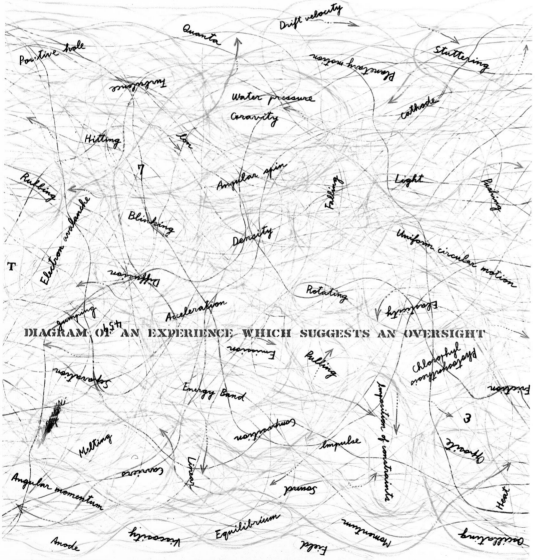

4 THE ENERGY OF MEANING

A STUDY OF SIGN PROCESS IN MOTION, AS MOTION; THIS
WILL INCLUDE A REPORT OF CURRENT THEORIES (BIOCHEMICAL,
PHYSICAL AND PSYCHOPHYSICAL ASPECTS) AS WELL AS
FURTHER SPECULATION

DIAGRAM OF AN EXPERIENCE WHICH SUGGESTS AN OVERSIGHT

GREY ARROWS – RANDOM ORGANIZING PRINCIPLES IN PRE-ENERGY STATE
WHITE ARROWS – REPRESENT THE UNSPECIFIED

WHATEVER IS NOT COVERED BY A WORD OR A WHITE OR GREY ARROW IN THIS DIAGRAM
REPRESENTS THE UNSUSPECTED AND THE BARELY SUSPECTED IN EVERY CONTEXT.
THE MANNER AND THE PURPOSE OF INDICATING THIS HERE HAVE TO DO WITH THE
SUSPICION OF THE CRUCIAL ROLE WHICH SUCH UNSUSPECTED (NON-EXISTENT?)
FORCES PLAY IN ESTABLISHING A GROUND.

Still missing from a world-view.

Essentially to reflect, deflect, inflect...
the texture of how....

Quantum as particle or wave.

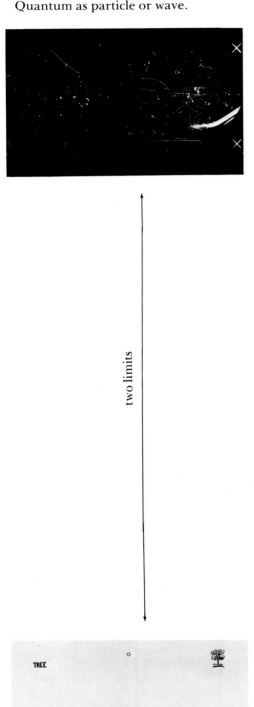

two limits

Chart for locating the blind spot.

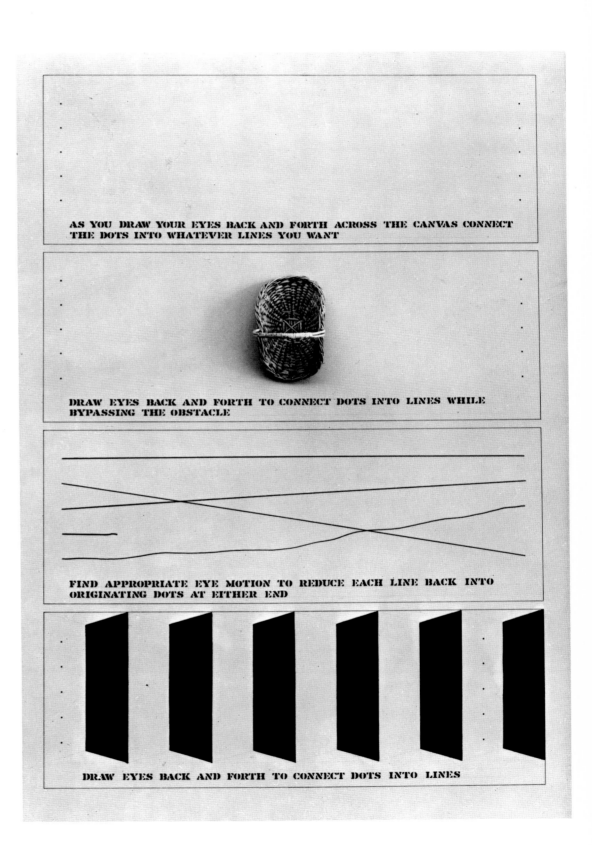

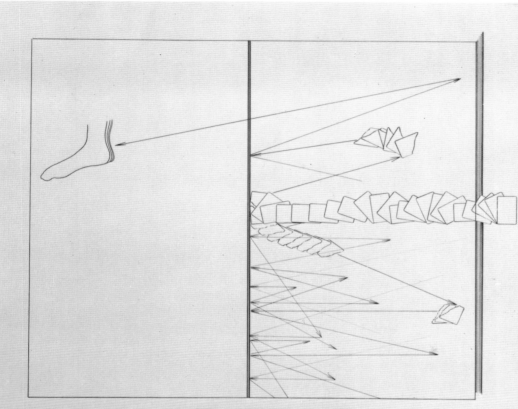

A CARD BECOMES A FOOT

Some formulas for working out about one or two percent of the details of the above diagram.

$* \quad P = momentum \quad m = mass \quad v = velocity \quad P = mv$

$*$ Newton's universal law of gravitation $\quad F = \dfrac{Gm_1 M_2}{R^2}$

$*$ First law of thermodynamics $\quad E = Q - W \quad Q -$ heat absorbed by system. $W -$ Work done on surroundings

$*$ Electrostatic potential energy $\quad \phi_e = \dfrac{q_1 q_2}{R}$

$*$ Coulomb's law for electrostatic forces $\quad F = \dfrac{q_1 q_2}{R} \quad R -$ distance between particles $q - q$

$*$ Transfer of energy and momentum by an electromagnetic wave

Energy crossing unit area per second $\quad S = \dfrac{CEB}{4\pi}$

Momentum crossing unit area per second $\quad P = \dfrac{S}{C} = \dfrac{EB}{4\pi}$

$*$ The Fitzgerald-Lorentz contraction for object moving with the velocity V, relative to the observer is contracted in the ratio $\sqrt{1 - \dfrac{V^2}{C^2}}$ in a direction parallel to its motion as compared with an identical object at rest relative to the observer.

$*$ Planck's quantum of energy $\quad c = h\nu \quad h = 6.625 \times 10^{-27}$ erg/sec

$*$ Variation of mass with velocity $\quad m = \dfrac{M_0}{\sqrt{1 - \dfrac{V^2}{C^2}}} \quad *$ Krebs citric acid cycle

$*$ The peptide bond — the carbonyl group $(-CO-)$ and the imino group $(-NH-)$

please write corrections or additions here \longrightarrow

As the director of the Nationalgalerie in Berlin was reviewing the installation of this project with his assistant the day before its opening at his museum in September of 1972, he stopped short in front of this panel. He became enraged. "How dare this artist write 'mistake' over the formulas of physics upon which our world is built!" he exclaimed. The assistant reports that if he hadn't restrained him, he might actually have kicked through the panel. When Arakawa was told of this event, he said that he would like to thank the director for having been concerned enough to make even more energy of meaning.

Oddly enough, at about the same time we learned that some physicists at a Berlin university, while studying mechanisms which distort any observation, had found nothing much to help until by chance one of them happened upon our book. As they later told us, it gave them a rather thorough—though peculiar—view of the various aspects of the problem.

LOOKING FOR A WORD BETWEEN FORMULATION AND ANGULAR

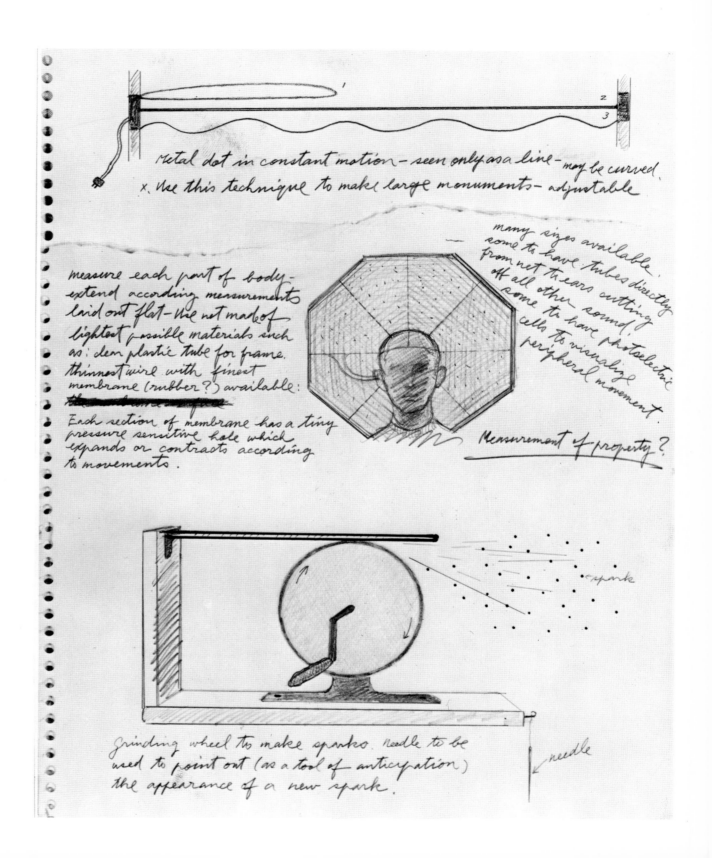

metal dot in constant motion — seen only as a line — may be curved.
x. Use this technique to make large monuments — adjustable

many sizes available.
some to have tubes directly
from net the ears cutting
off all other sound.
some to have photoselectric
cells to visualize
peripheral movement.

measure each part of body —
extend according measurements
laid out flat — the net made of
lightest possible materials such
as: clear plastic tube for frame.
thinnest wire with finest
membrane (rubber?) available:

Each section of membrane has a tiny
pressure sensitive hole which
expands or contracts according
to movements.

Measurement of property?

spark

grinding wheel to make sparks. needle to be
used to point out (as a tool of anticipation)
the appearance of a new spark.

needle

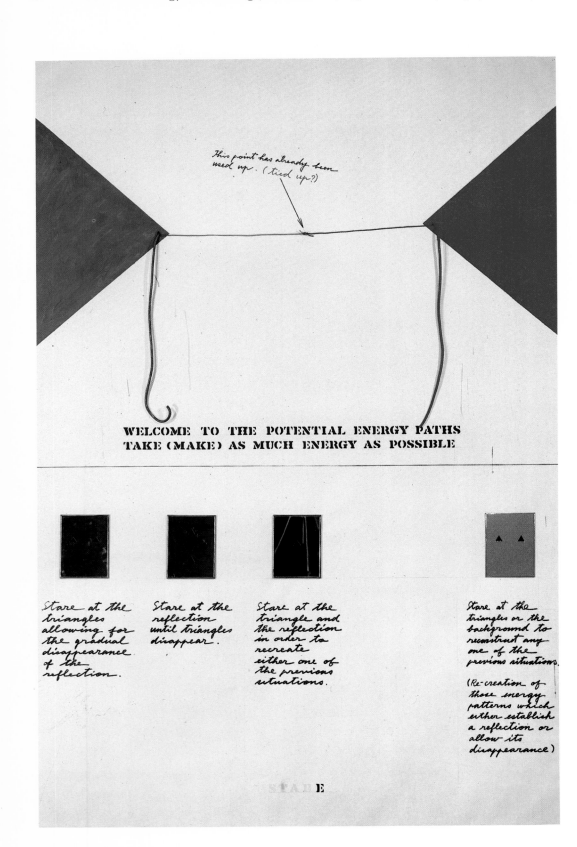

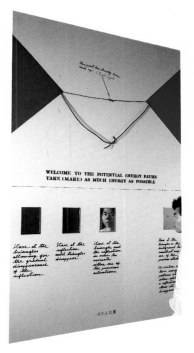

To stockpile vision

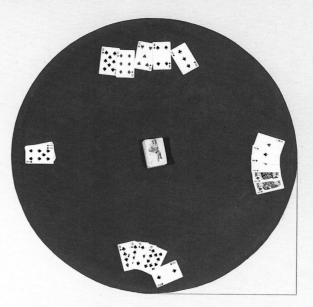

5 DEGREES OF MEANING

EXERCISES TO STUDY THE OPERATION OF ABSTRACTION
THROUGH THE ALTERATION OF SIGNIFICATIONS BY DEGREES
(ANGLE , POSITION , INTENSITY , PERSPECTIVE , ⋯) AND THE
RANGE OF THIS NOTION OF DEGREES IN ABSTRACTION THROUGH
EXTENSIVE COMPARISON OF THESE . (TO SURROUND 'DEGREE'
BY DEGREES ?)

USE THE FACT THAT:

THE ABOVE OBJECT (*Everything in the above object*)

THE ABOVE PAINTING ()

THE ABOVE GAME (*Games*)

THE ABOVE STRUCTURE (*The structure of the structure*)

THE ABOVE DIAGRAM(*Diagram* ?)

IS ISOMORPHIC TO <u>ANYTHING</u>

(CHAIR , LANDSCAPE , AIRPLANE , HAND , CAKE , ETC ⋯)

TO SURROUND DEGREE BY DEGREES

THE ABOVE SOUND

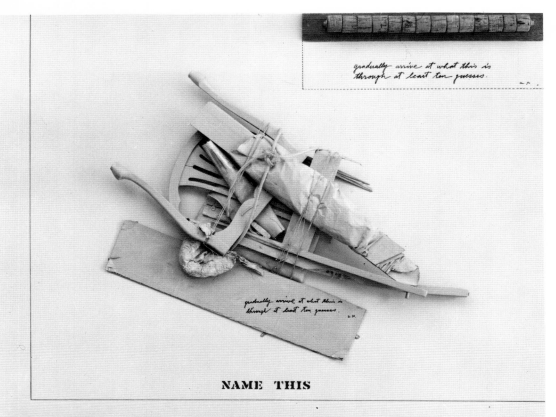

gradually arrive at what this is through at least ten guesses.

NAME THIS

NAME THIS

THE TWO AREAS SEPARATED BY THE GRAY STRIP (MOVABLE) SHOULD NEVER BE UNITED IN ONE PERCEPTION

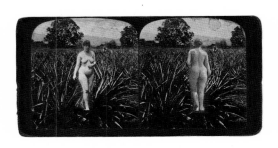

Use neither stereopticon nor monocle.

These are all the same size.

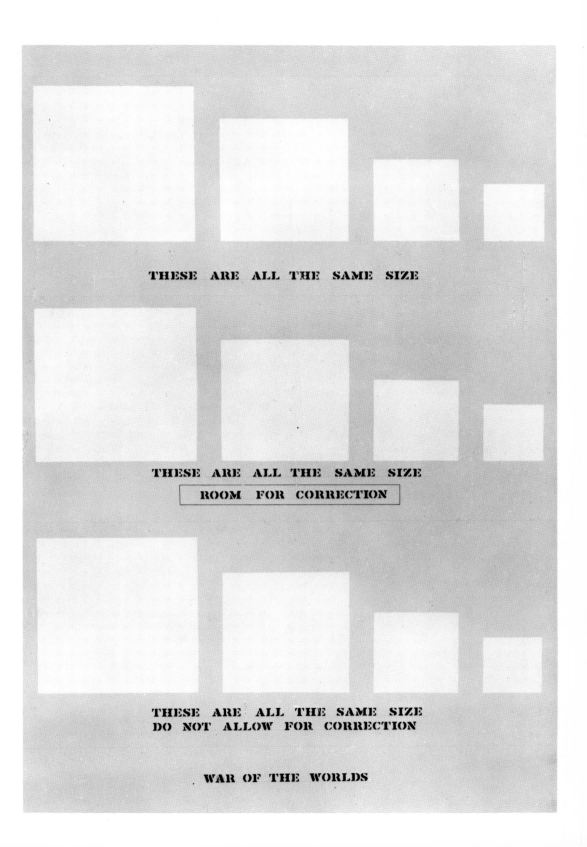

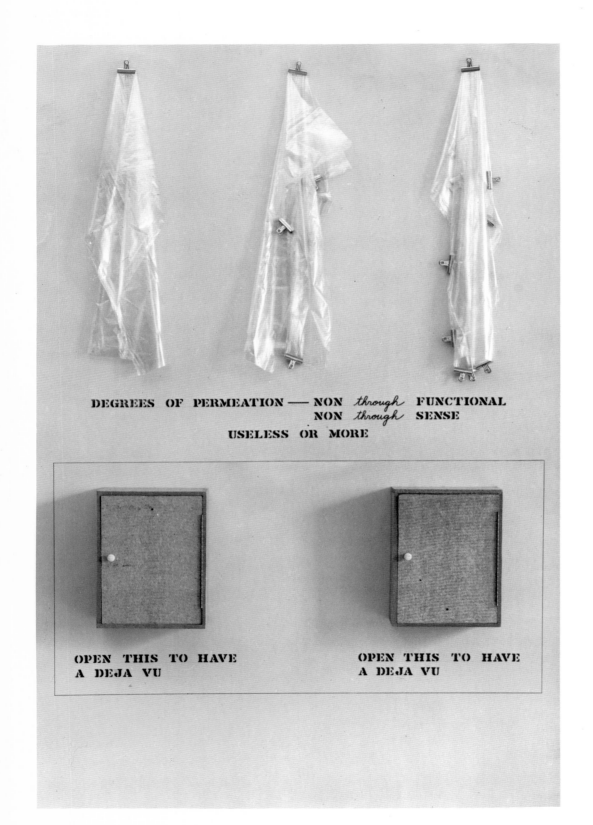

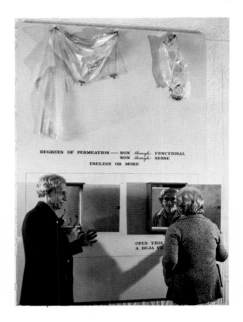

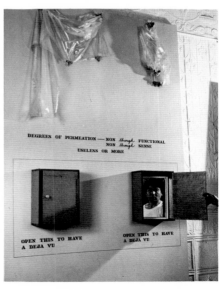

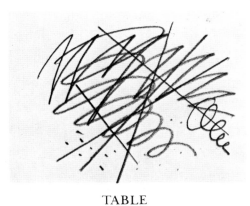

TABLE

A PRE-THOUGHT WHICH OCCURRED
DURING AN AFTER-THOUGHT

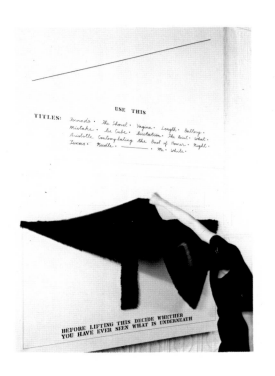

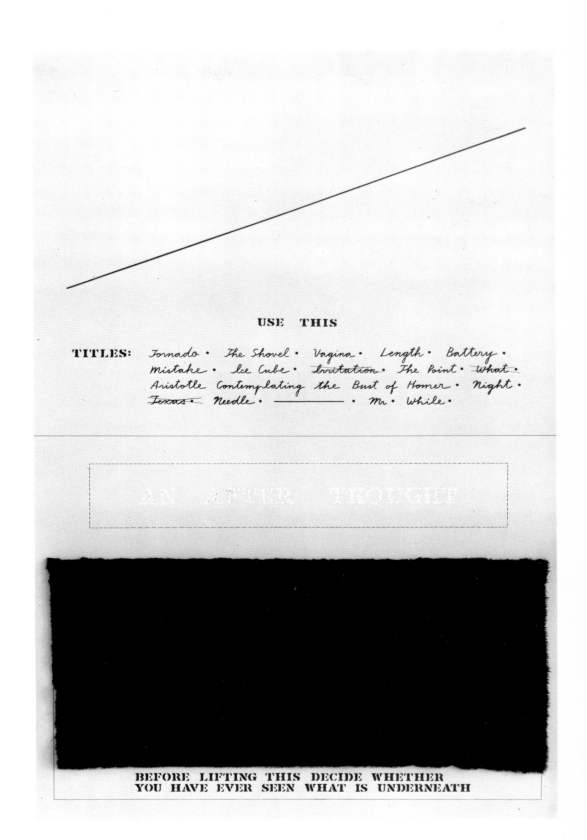

USE THIS

TITLES: *Tornado* • *The Shovel* • *Vagina* • *Length* • *Battery* •
Mistake • *Ice Cube* • ~~*Invitation*~~ • *The Point* • ~~*What*~~ •
Aristotle Contemplating the Bust of Homer • *Night* •
~~*Texas*~~ • *Needle* • ———— • *Mr.* • *While* •

AN AFTER THOUGHT

BEFORE LIFTING THIS DECIDE WHETHER
YOU HAVE EVER SEEN WHAT IS UNDERNEATH

A B C D E F G H I J K L MZ

1234 5 6 78 9

CAT RAN MAT DOG HAT COW GOT BOY

WHISPER WHISTLE COVER PAIR WOOL SHEEP

NEVER MIND WHAT HE SAYS

HOPE TO SEE YOU SOON AGAIN

Attempt to pronounce each of these with mouth closed (with or without tape)

KINAESTHETIC SCULPTURE

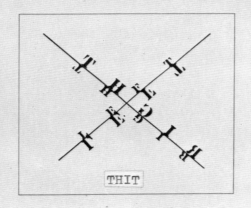

THIT

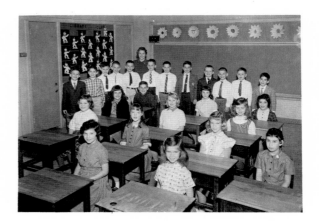

to narrow in…to narrow out…

 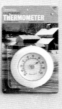

VARY THE RATE OF PRONUNCIATION ACCORDING TO THE LENGTH OF TIME SPENT TOUCHING THE OBJECT

T H A S

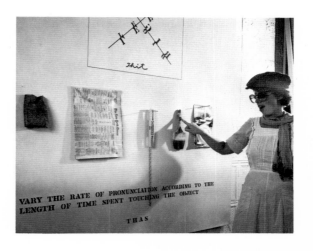

VARY THE RATE OF PRONUNCIATION ACCORDING TO THE LENGTH OF TIME SPENT TOUCHING THE OBJECT

THAS

SCALE OF ACTION

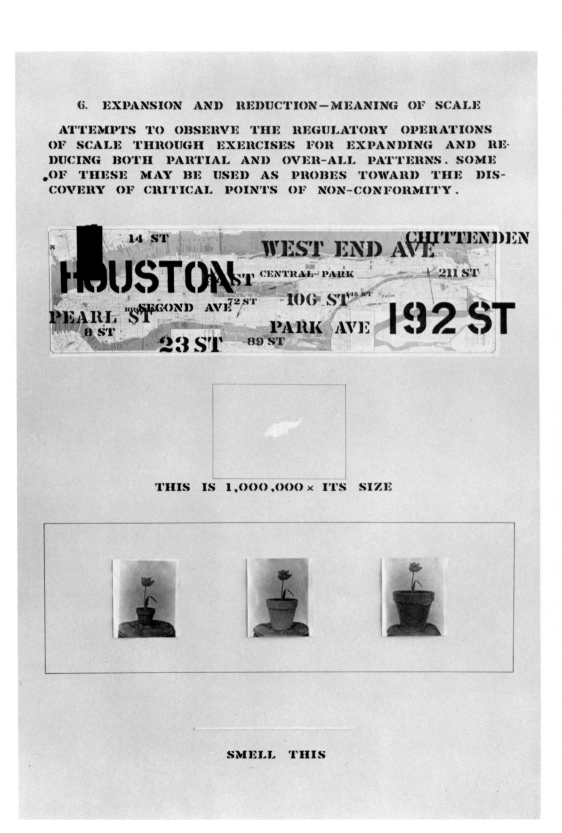

6. EXPANSION AND REDUCTION—MEANING OF SCALE

ATTEMPTS TO OBSERVE THE REGULATORY OPERATIONS OF SCALE THROUGH EXERCISES FOR EXPANDING AND REDUCING BOTH PARTIAL AND OVER-ALL PATTERNS. SOME OF THESE MAY BE USED AS PROBES TOWARD THE DISCOVERY OF CRITICAL POINTS OF NON-CONFORMITY.

THIS IS 1,000,000 × ITS SIZE

SMELL THIS

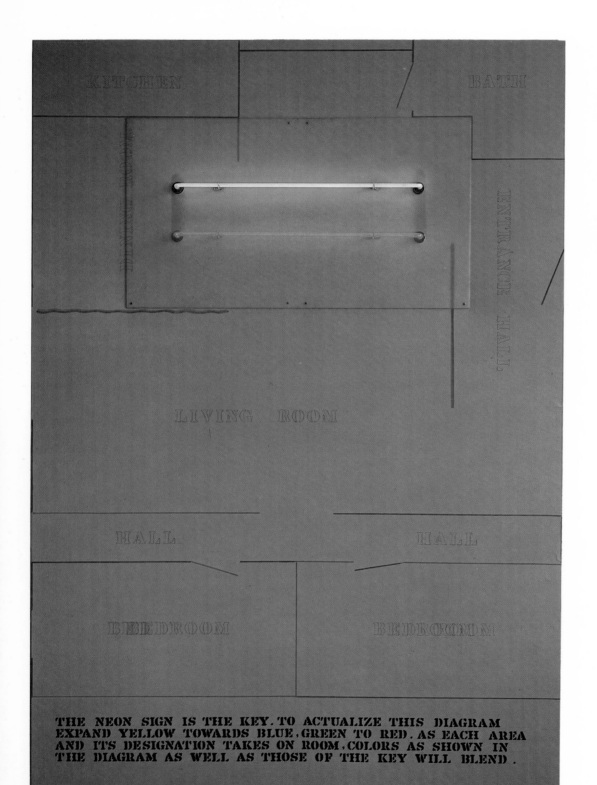

KITCHEN BATH

ENTRANCE HALL.

LIVING ROOM

HALL HALL

BEDROOM BEDROOM

THE NEON SIGN IS THE KEY. TO ACTUALIZE THIS DIAGRAM
EXPAND YELLOW TOWARDS BLUE, GREEN TO RED. AS EACH AREA
AND ITS DESIGNATION TAKES ON ROOM. COLORS AS SHOWN IN
THE DIAGRAM AS WELL AS THOSE OF THE KEY WILL BLEND.

SHADOW OF THIS DIAGRAM

Never to be built unless on most noisy street.

nation for Paul Kosok of Long Islan
University, a student of pre-Columb
an South America. Some 40 years ag
while he was mapping what he too

(more than?)
The Parallel Guess
Context versus Text Alone

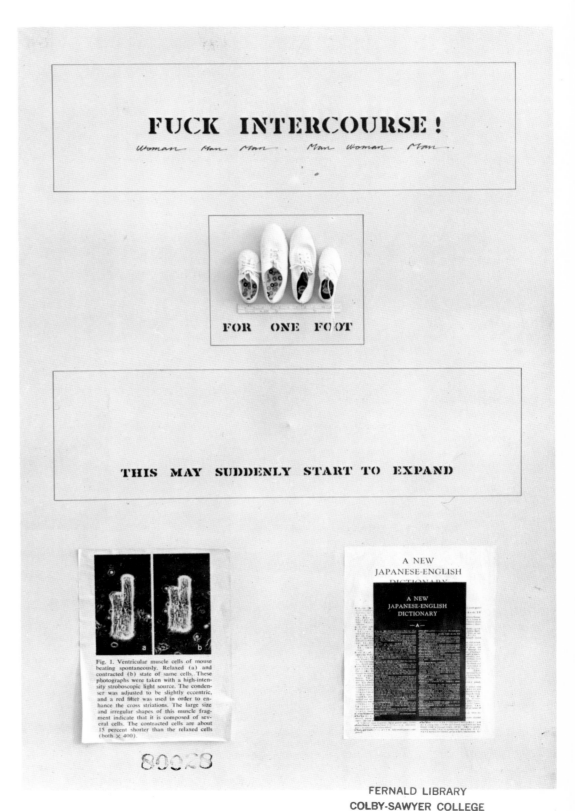

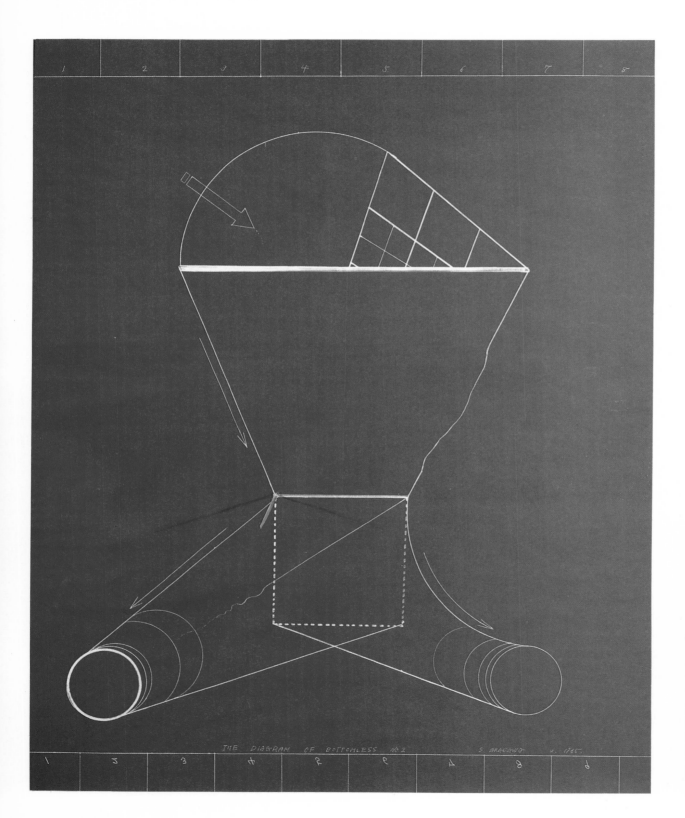

THE DIAGRAM OF BOTTOMLESS NO.2 S. ARAKAWA d. 1965.

"thereness" or "presence to"

Detail(s)

Ignore details.

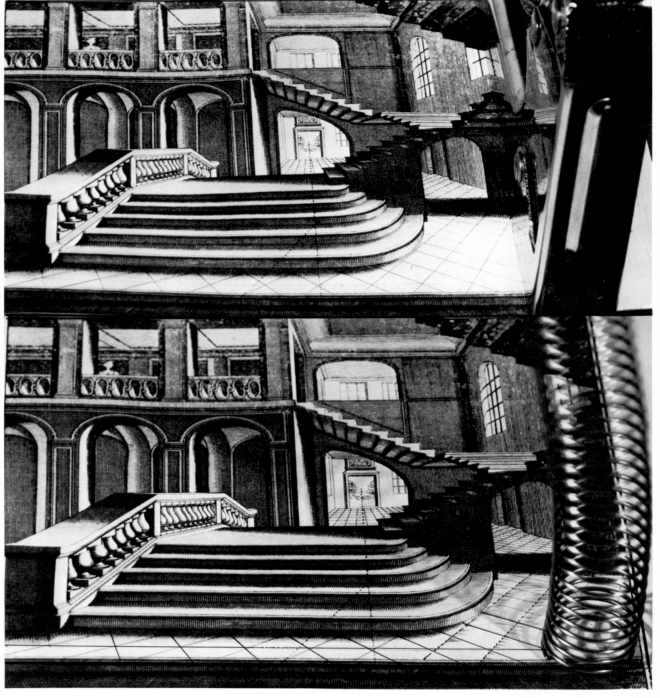

MONOLITHIC SENSIBILITIES?

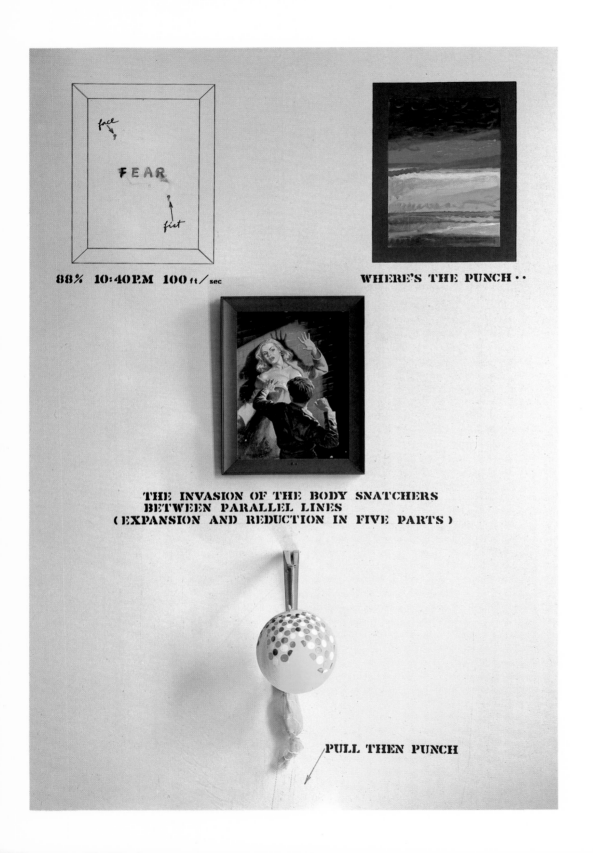

88% 10:40 P.M. 100 ft/sec

WHERE'S THE PUNCH··

THE INVASION OF THE BODY SNATCHERS
BETWEEN PARALLEL LINES
(EXPANSION AND REDUCTION IN FIVE PARTS)

PULL THEN PUNCH

ThEnigma

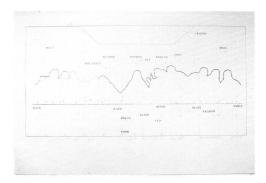

NEXT TO THE LAST

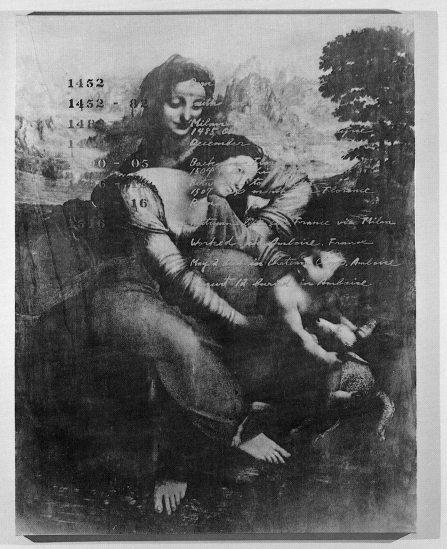

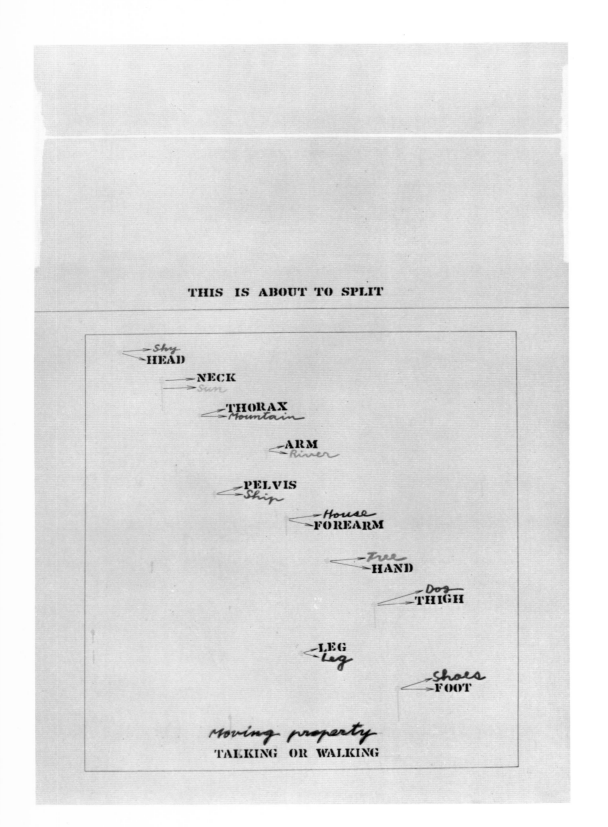

THIS IS ABOUT TO SPLIT

→ *Sky*
→ **HEAD**

→ **NECK**
 → *Sun*

→ **THORAX**
 → *Mountain*

→ **ARM**
 → *River*

→ **PELVIS**
 → *Ship*

→ *House*
→ **FOREARM**

→ *Tree*
→ **HAND**

→ *Dog*
→ **THIGH**

→ **LEG**
 → *Leg*

→ *Shoes*
→ **FOOT**

Moving property
TALKING OR WALKING

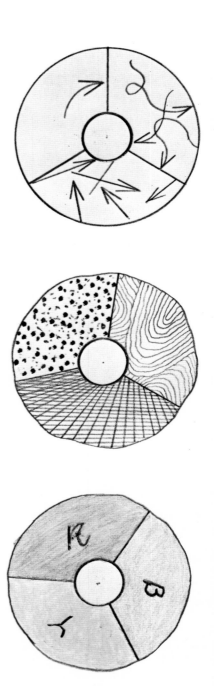

SOME REPRESENTATIVE SPLITS

Name Impasse.

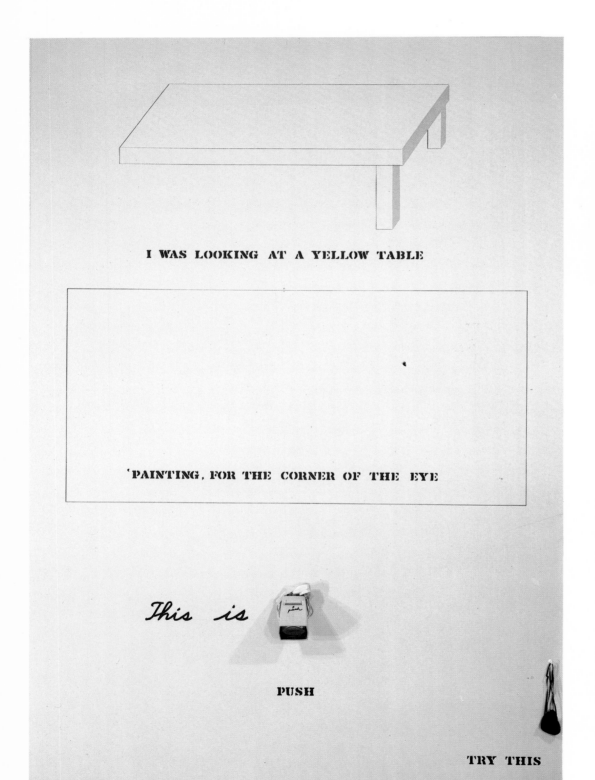

Peripheral photo.

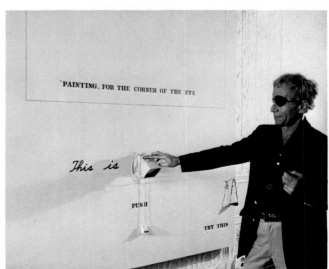

Which one is closer to three or four dimensions? ▶

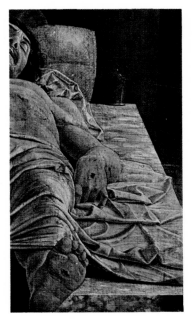

Andrea Mantegna. *Dead Christ* ½.
Pinacoteca di Brera, Milan.

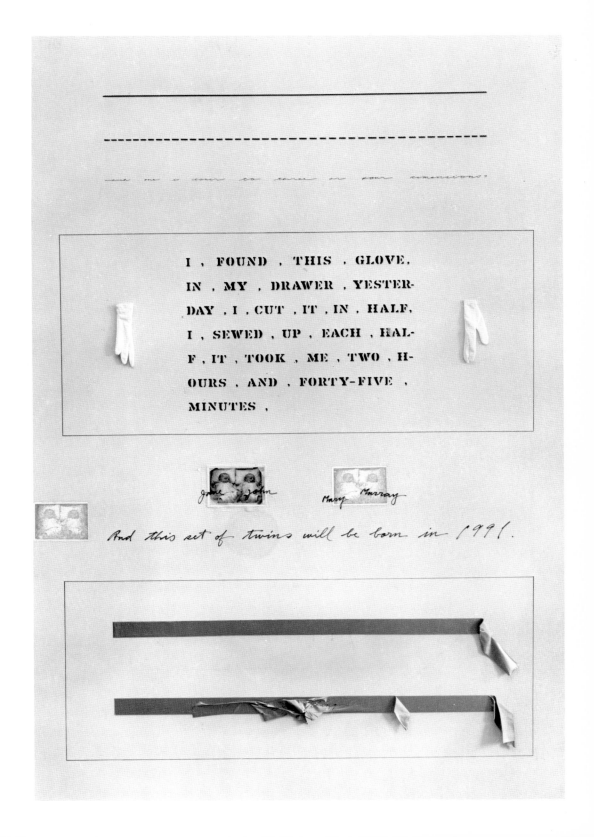

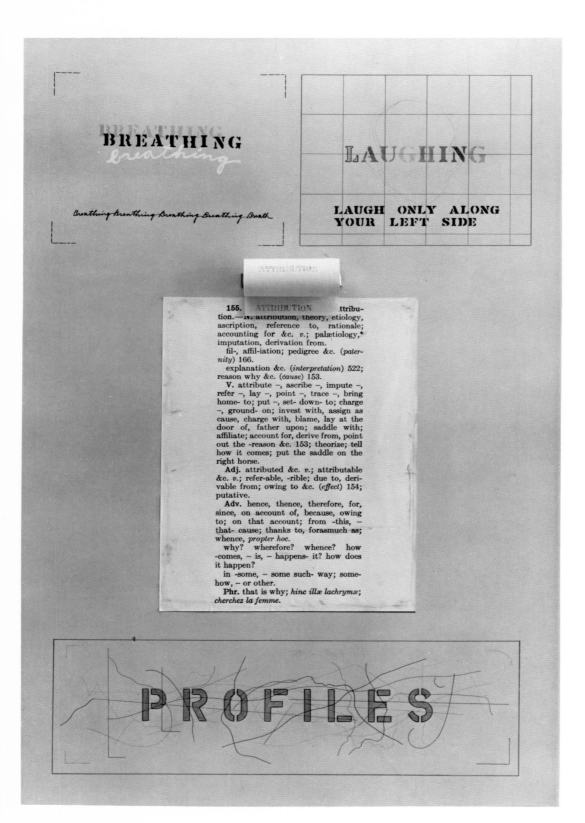

8 REASSEMBLING

AN INVESTIGATION OF THE ELEMENTS OF REASSEMBLY AND OF THE POSSIBLE APPLICATIONS OF THESE IN ORDER TO CHANGE USAGE

A + B = C

Brown pink

TO WHAT EXTENT IS = A FUNCTION OF + ?

The range of values for each + and = is wide open as long as the above relations hold.
Other considerations are: A + + + + + B = C . A + B = C
Color, positional changes in A. B
If + is ten years (minutes) ahead of =
Or a shift in any other dimension

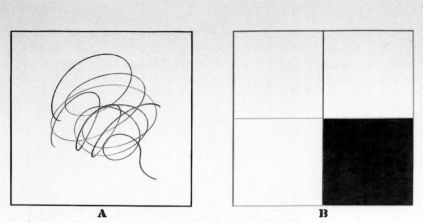

A B

PERCEIVE A AS B

IMMEDIATELY UPON RECOGNITION OF THIS PROBLEM, SOLUTION
MAY BE PROVIDED (TRIGGERED BY UNDERLYING SIMILARITIES?)
BY AN INSTANTANEOUS DIVERSION OF A INTO B. IF NOT, THE
FOLLOWING EXERCISES MAY AID SUBSEQUENT TRANSFORMATIONS

PREPARATIONS OR ELEMENTS FOR REASSEMBLY

1 DIFFUSION

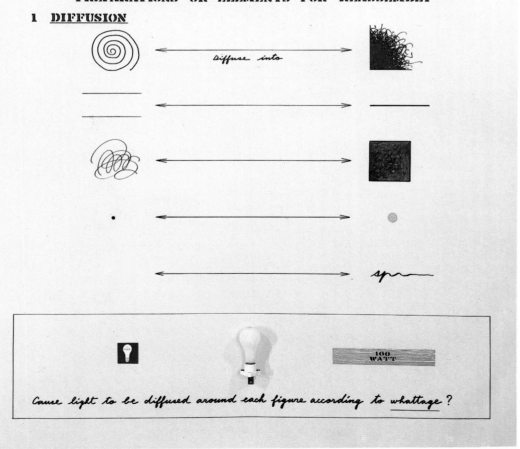

Diffuse into

*100
WATT*

Cause light to be diffused around each figure according to whattage?

A

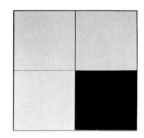

B

PERCEIVE A AS B

A

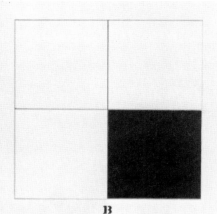

B

2 <u>**REMOVAL**</u>

TRANSPOSE , SEPARATE , D
ISPLACE , WITHDRAW , CHA
NGE , DEDUCT , REMOVE , E
MPTY , TRANSPLANT , TAK
E OFF , SUBTRACT , GOOD -
BYE , ABSTRACT , TRANSF
ER , BE GONE , PULL OFF , T
RANSMIT , PUSH OUT , BY

A'

B

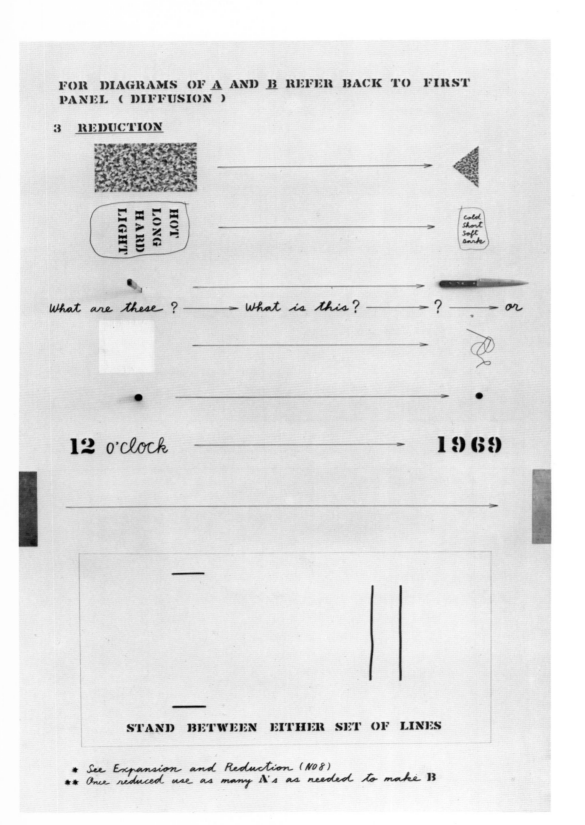

FOR DIAGRAMS OF **A** AND **B** REFER BACK TO FIRST PANEL (DIFFUSION)

3 REDUCTION

HOT LONG HARD LIGHT → Cold Short Soft donte

What are these? ——→ What is this? ——→ ? ——→ or

12 o'clock ————————→ 1969

STAND BETWEEN EITHER SET OF LINES

* See Expansion and Reduction (NO 8)
** Once reduced use as many A's as needed to make B

A B

PERCEIVE A AS B

A

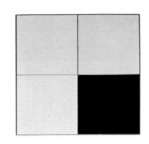

B

PERCEIVE A AS B

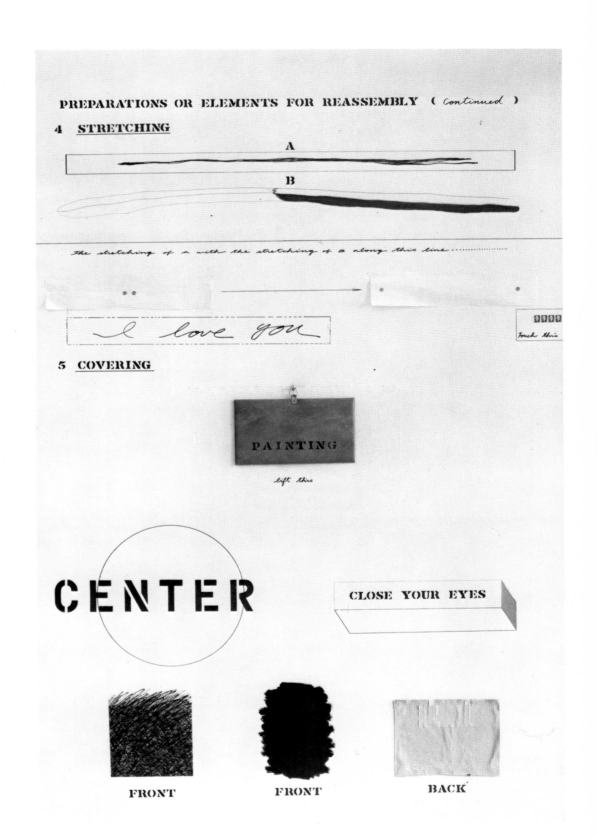

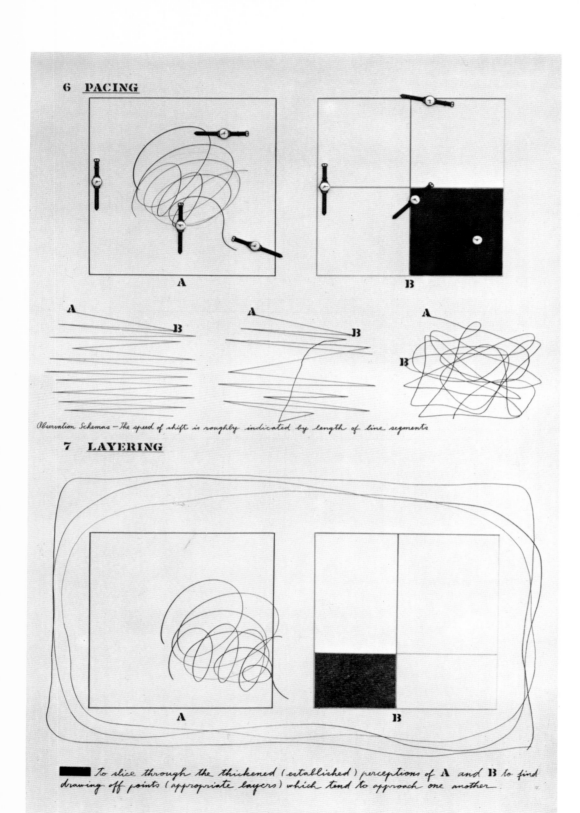

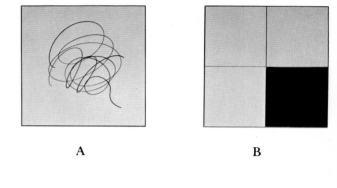

A B

PERCEIVE A AS B

Observation schemas—the speed of shift is roughly indicated by length of line segments.

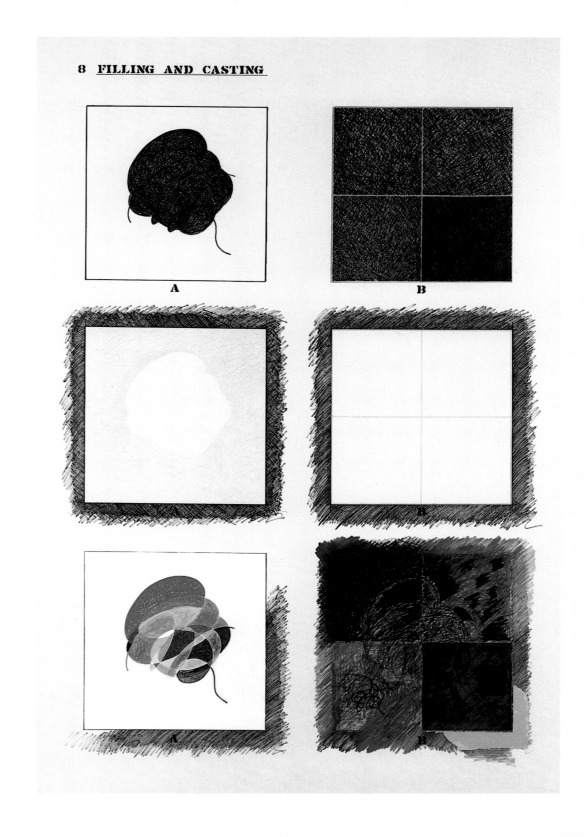

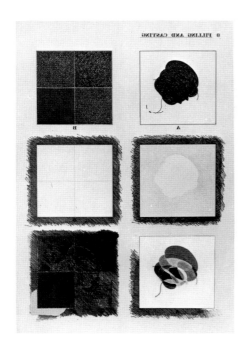

9 MEASURING (JUDGING)

 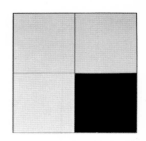

DECIDE WHICH EACH OF THESE RESEMBLES MOST A OR B

WHICH WOULD BE MORE USEFUL FOR MEASURING THIS A OR B ?

> ESTIMATE THE EFFECT OF:
> *diffusion × diffusion − diffusion*
> *removal + covering*
> *pacing + layering − filling and casting*
> *reduction + stretching*

A' B'

PERCEIVE A' AS B'
HOW MUCH MORE DIFFICULT IS THIS
PROBLEM THAN ITS PROTOTYPE ?

Look at A with a loud voice

A is B

What is the farthest distance possible between A and B ?

Roll A into B, relax A into B, dip A into B, etc

Which took longer to make A or B ?

A B

PERCEIVE A AS B

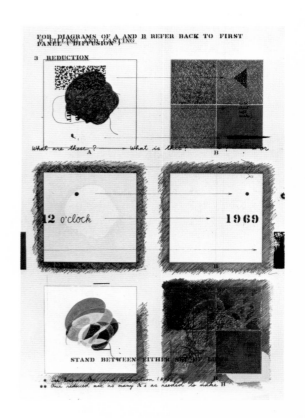

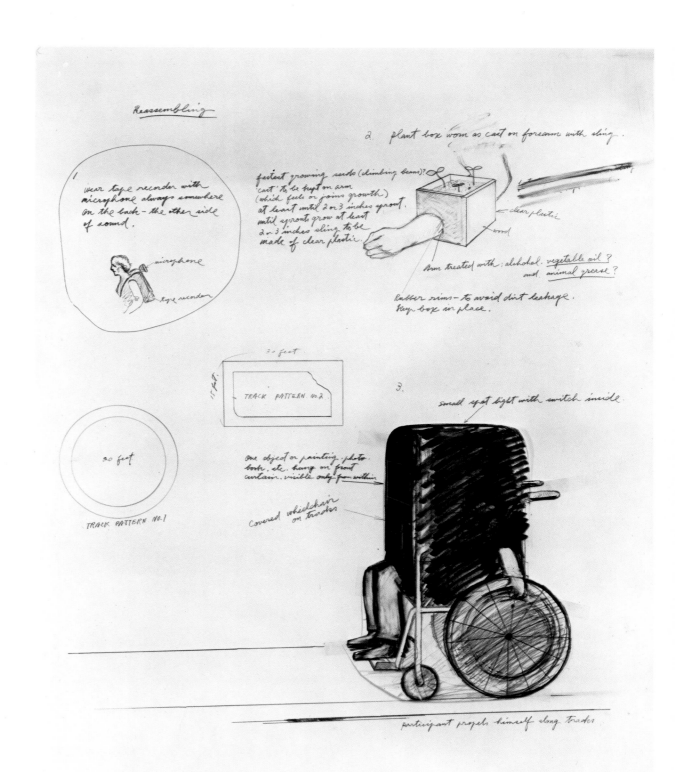

9 REVERSIBILITY

TO STRETCH THE CONCEPT OF BEING ABLE TO BE REVERSED
WHILE EXPLORING THE FLEXIBILITY OF SUCH NOTIONS AS
POSITION, CHANGE, SYMMETRY, ETC. (ALTHOUGH THIS IS
CLOSELY RELATED TO SEVERAL OTHER SUBDIVISIONS IT IS
FELT THAT A SEPARATE INVESTIGATION MAY PROVE USEFUL)

EXTRA

A MNEMONIC DEVICE

LOOK AT THIS FOR MORE THAN ONE MINUTE TO KEEP YOUR OWN NAME

A MNEMONIC DEVICE FOR FORGETTING

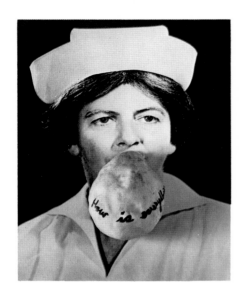

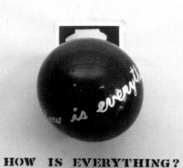

HOW IS EVERYTHING?

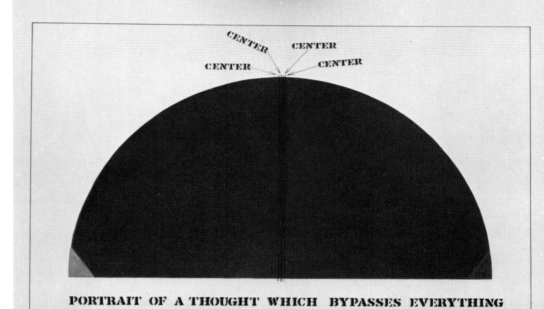

PORTRAIT OF A THOUGHT WHICH BYPASSES EVERYTHING

PEOPLE
AIR
WATER
ART

SUBJECT TO REVERSALS

SUN	MON	TUE	WED	THU	FRI	SAT
			30	29	28	27
26	25	24	23	22	21	20
19	18	17	16	15	14	13
12	11	10	9	8	7	6
5	4	3	2	1		

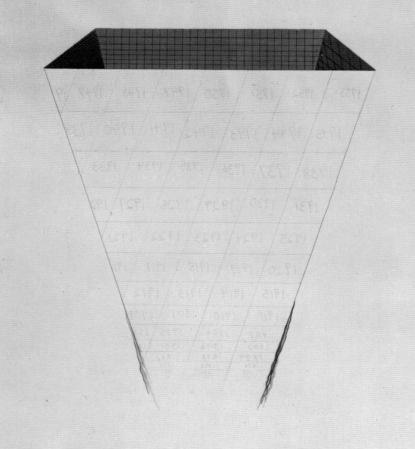

WHAT HAVE YOU FORGOTTEN?
WHAT HAS BEEN FORGOTTEN?
WILL YOU WERE?
WILL YOU REMEMBERED?

Difference and Idea

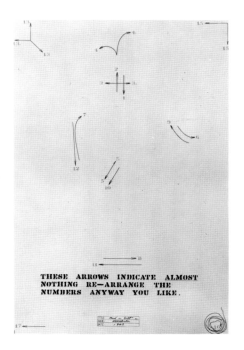

THESE ARROWS INDICATE ALMOST
NOTHING RE—ARRANGE THE
NUMBERS ANYWAY YOU LIKE.

Core of flexibility only.

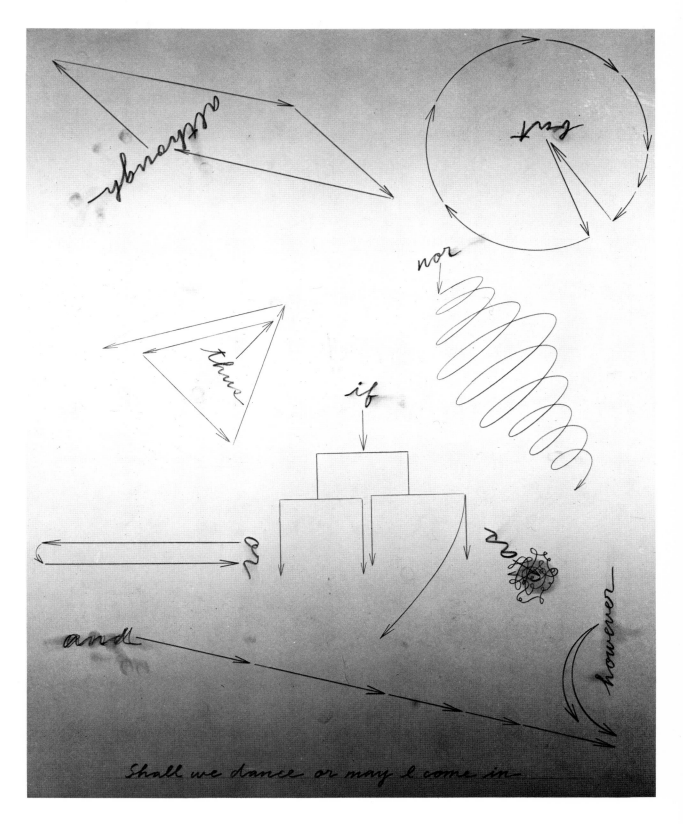

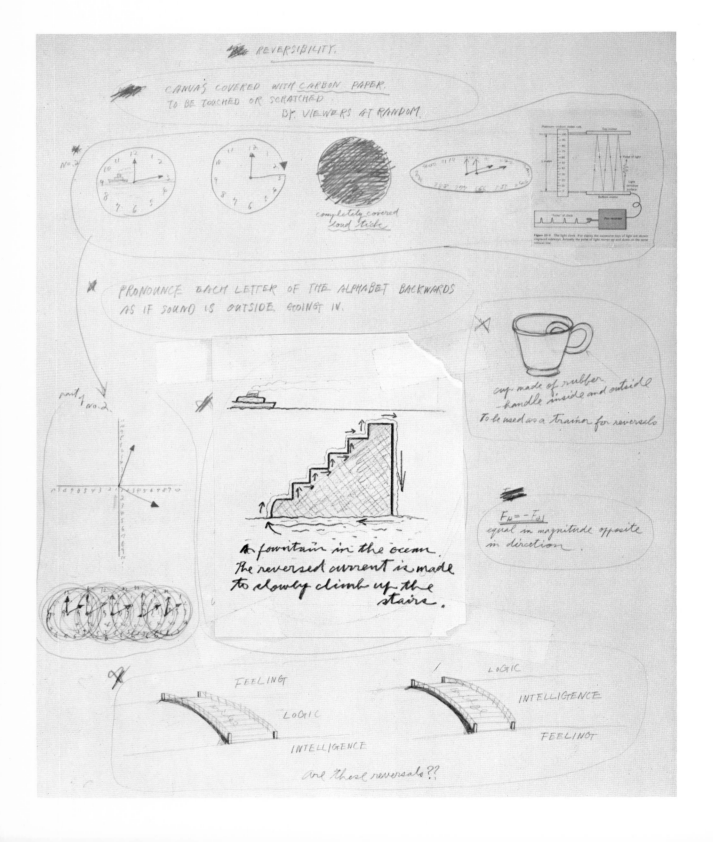

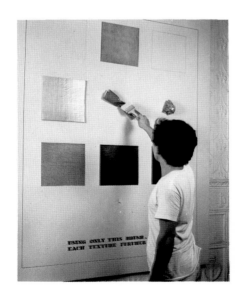

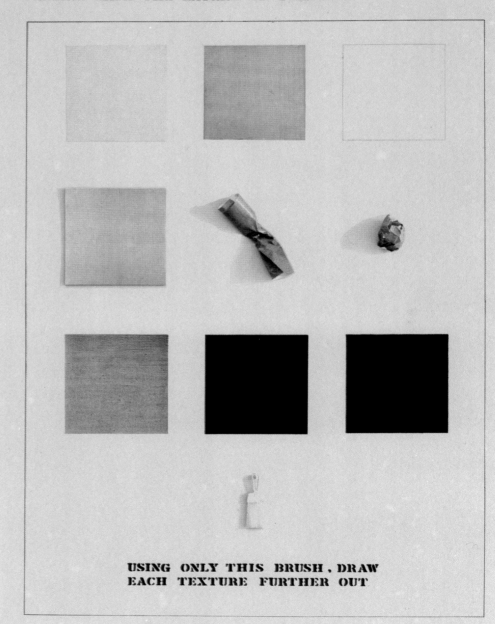

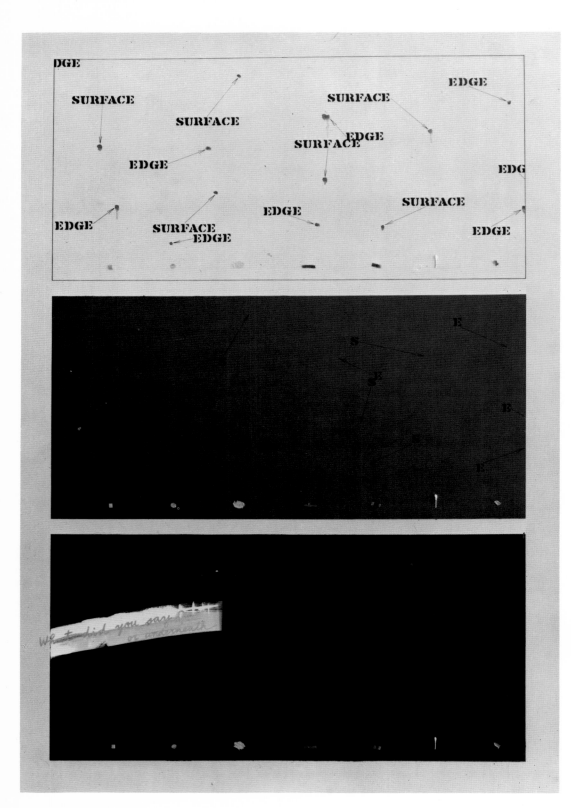

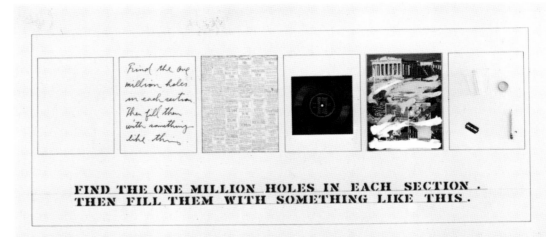

FIND THE ONE MILLION HOLES IN EACH SECTION .
THEN FILL THEM WITH SOMETHING LIKE THIS .

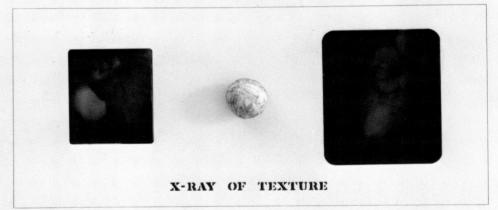

X-RAY OF TEXTURE

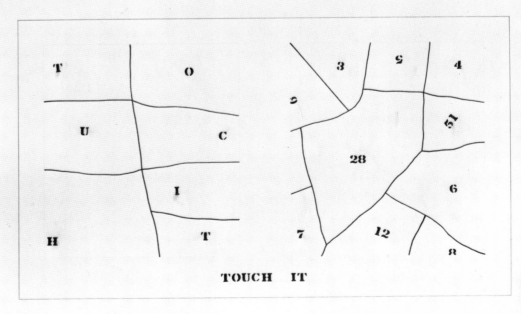

TOUCH IT

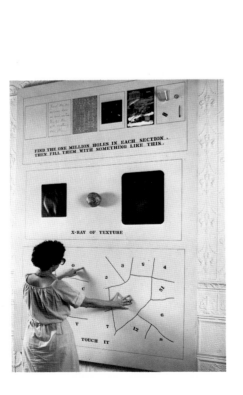

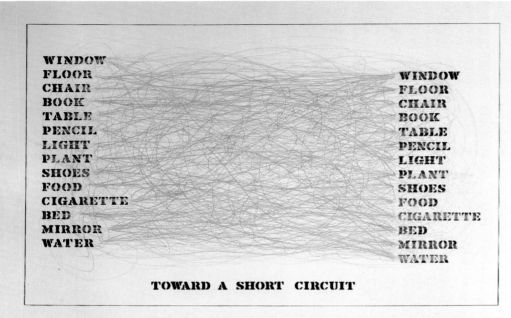

WINDOW
FLOOR
CHAIR
BOOK
TABLE
PENCIL
LIGHT
PLANT
SHOES
FOOD
CIGARETTE
BED
MIRROR
WATER

WINDOW
FLOOR
CHAIR
BOOK
TABLE
PENCIL
LIGHT
PLANT
SHOES
FOOD
CIGARETTE
BED
MIRROR
WATER

TOWARD A SHORT CIRCUIT

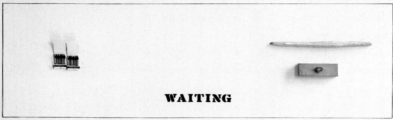

WAITING

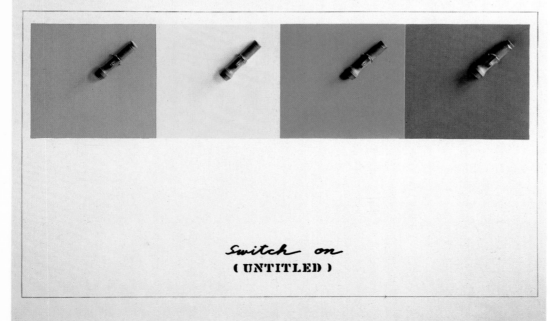

Switch on
(UNTITLED)

Vibrating disappearance.
Surface of repetition.

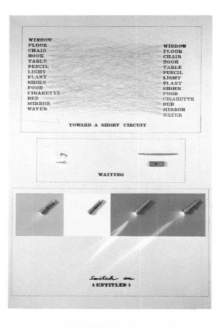

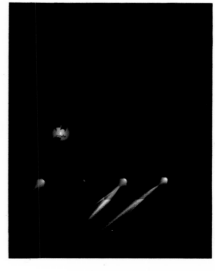

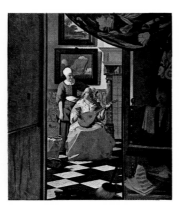

In the event of three or more textures, which is nearest? Find the dividing points.

COULD THERE BE→

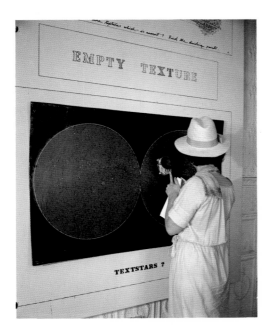

When the button is pressed, a voice is heard. This time it said: "May I walk to school with you?"

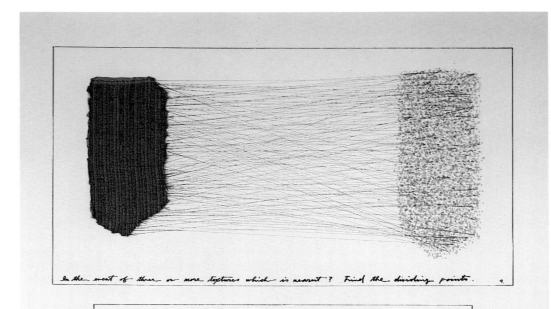

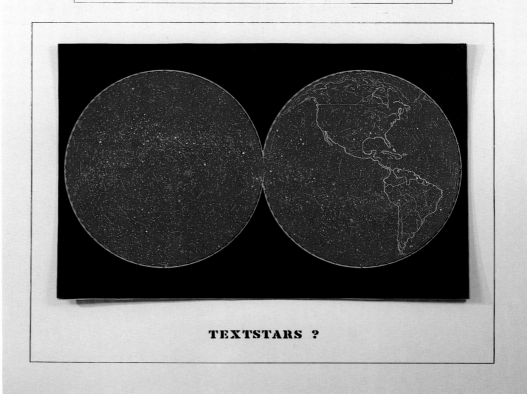

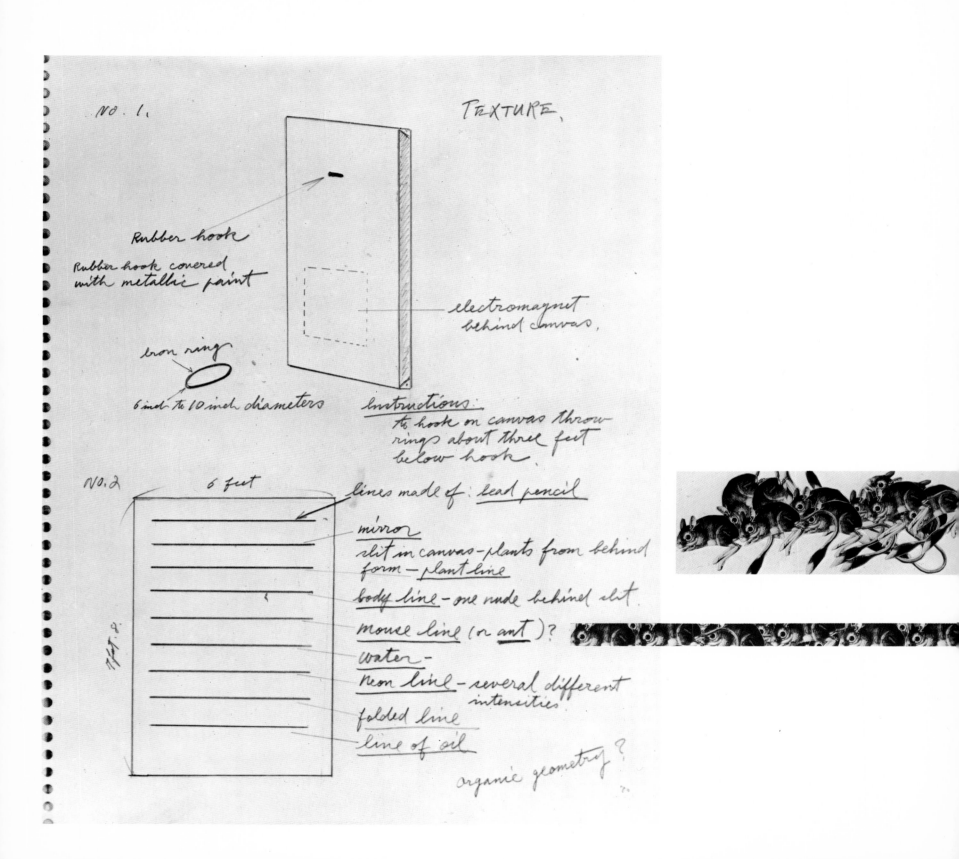

No. 1. TEXTURE.

Rubber hook
Rubber hook covered
with metallic paint

electromagnet
behind canvas.

iron ring

6 inch to 10 inch diameters

Instructions:
to hook on canvas throw
rings about three feet
below hook.

No. 2 6 feet lines made of : lead pencil

mirror
slit in canvas — plants from behind
form — plant line

body line — one nude behind slit.

Mouse line (or ant)?

water —

Neon line — several different
 intensities

folded line

line of oil

organic geometry ?

11. MAPPING OF MEANING

CONSIDER THAT ANY REPRESENTATION OR SYSTEM MAY BE USED AS A MAP WHEN PAIRED WITH OR PLOTTED AGAINST AN OBJECT OR AN ENVIRONMENT. THIS SECTION DEALS WITH RE-PRESENTATIONS OF: THE PROCESS OF MAPPING ITSELF; THE DOUBLE ASPECT OF SIGN; THE RELATION OF DENOTATION TO CONNOTATION (PROPERTY OF MEANING); THE RELATIONS OF SIGNIFIEDS TO EACH OTHER. USE WILL BE MADE OF PROJECTION, DISTORTION AND 'NEGATIVE' MAPPING IN AN EFFORT TO SURROUND AND SUGGEST THE ARRANGEMENTS OF AREAS OF MEANING.

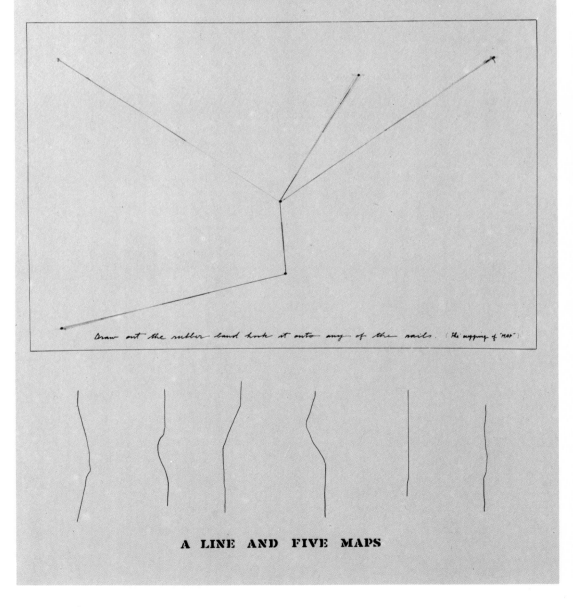

A LINE AND FIVE MAPS

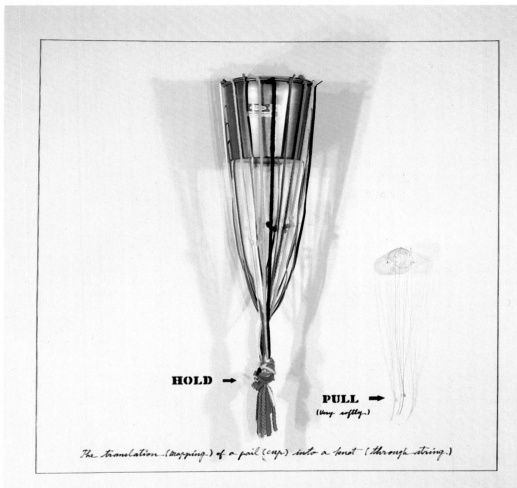

HOLD →

PULL →
(very softly)

The translation (mapping) of a pail (cup) into a knot (through string)

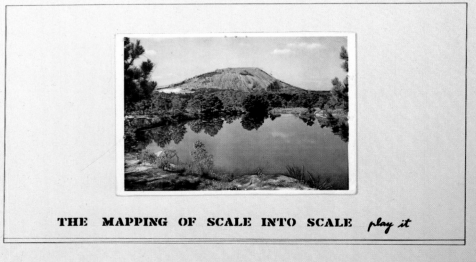

THE MAPPING OF SCALE INTO SCALE *play it*

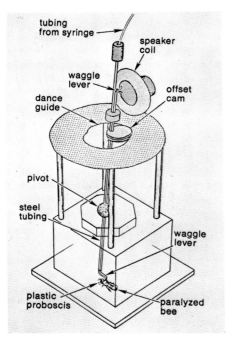

Model of a Bee

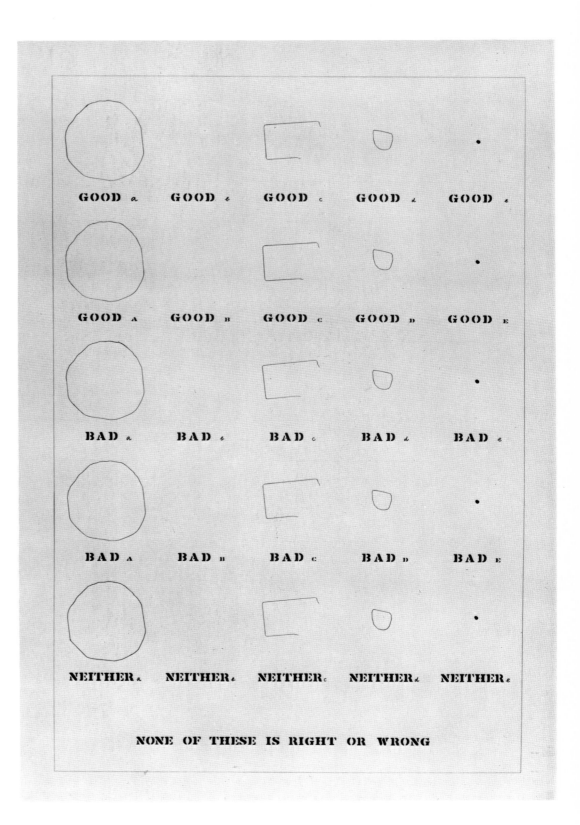

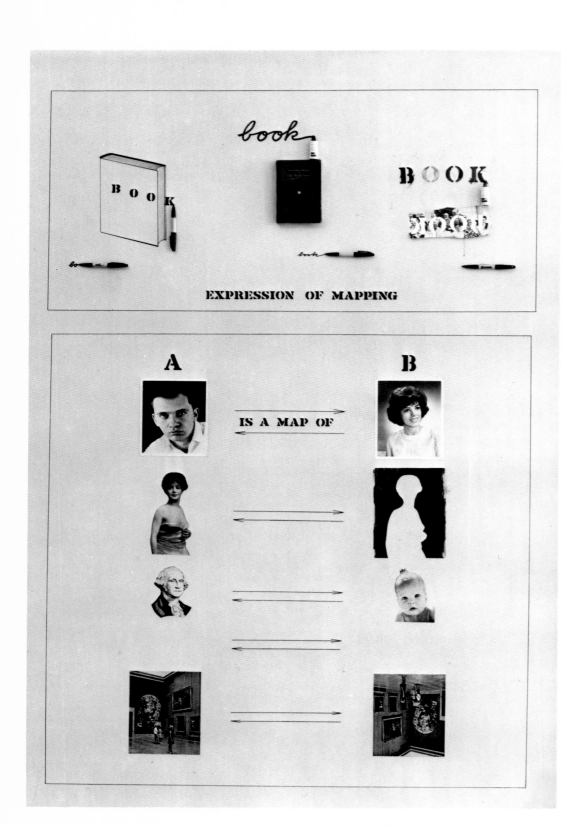

This pen has a limited capacity of either 400 words or 10 meters.

WET CONDITION OF ABSENCE

"Do you have a map?"

"Of what?"

"Anything?"

"Yes, I have a map of myself."

"Do you mean a mirror?"

"No, I mean a map, one I was born carrying."

"Oh, may I see it?"

"You *are* seeing it, more than I am, I think. Perhaps just a cross-section, but.... Anyway, because of you I can see my map better."

"Really? How good is it, anyway?"

"I don't know yet."

MAP OF AN AREA FOR A MAP

15 % of the dots move forward.
18 % of the dots move toward the left.
35 % move toward the right.
8 % move away.
11 % move back and forth.
3 % are sliding.
4 % are scrambling.
6 % are not apparent.

15 % of the dots moves forward.
18 % of the dots moves toward the left.
35 % moves toward the right.
8 % moves away.
11 % moves back and forth.
3 % is sliding.
4 % is scrambling.
6 % is not apparent.

12. THE FEELING OF MEANING

TOWARD A DEMONSTRATION OF THE AFFECTIVE ROLE IN COGNITION THROUGH AN INVESTIGATION OF AFFECTIVE VALUE AS A MEASURING DEVICE; EXERCISES FOR THE MOVEMENT OF EMOTIONS IN AN ATTEMPT TO SET PARAMETERS FOR FEELING THROUGH CONTORTION, OVERLAY, REVERSAL AND OTHER DIS — RUPTIVE SYSTEMS . ASSUMING THE VALIDITY OF THE JAMES —— LANGE THEORY, IF THERE IS AN INTERNAL SENSORY BASIS FOR FEELING , WHAT IS THE MEANING OF THIS PERCEPTION ?

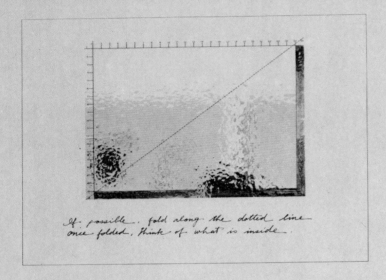

If possible . fold along the dotted line
once folded , think of what is inside .

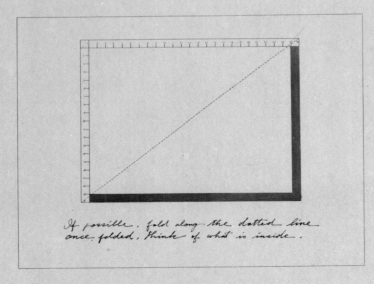

If possible . fold along the dotted line
once folded , think of what is inside .

Unit of emphasis.

1. This electric light is flashing off and on.

2. A wide variety of spiral filaments move about constantly picking up material and contributing to explosions (large and small).

3. This octagon is based on a split-second view of the original hexagonal structure which tends to elude perception due to the unique nature of its material and the speed at which it travels.

4. When spirals pass through magnetic currents, explosions may be intensified and a distinctive sound is heard.

5. These raised letters (2 to 3 inches thick) are melting towards the center.

6. The colors which are emitted during the explosions are made of almost no material. When the light is off material will be sensed first rather than color.

7. This self-centering pole which can never be seen is alternately hard and soft according to its own pressure system.

8. The dark section represents a hole to be continued for a million miles cutting through thousands of walls and other objects. The actions seen through it may be thought of as a contributing spray.

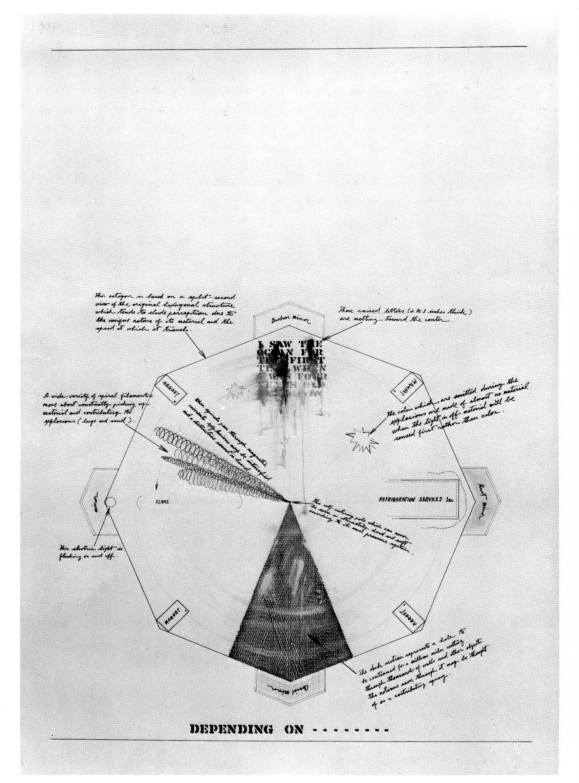

1967, New York

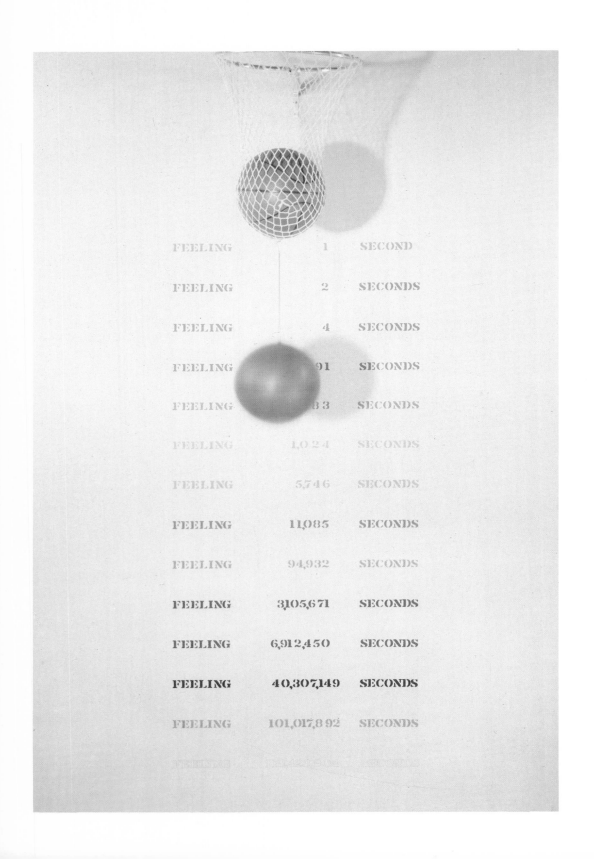

FEELING	1	SECOND
FEELING	2	SECONDS
FEELING	4	SECONDS
FEELING	91	SECONDS
FEELING	83	SECONDS
FEELING	1,024	SECONDS
FEELING	5,746	SECONDS
FEELING	11,085	SECONDS
FEELING	94,932	SECONDS
FEELING	3,105,671	SECONDS
FEELING	6,912,450	SECONDS
FEELING	40,307,149	SECONDS
FEELING	101,017,892	SECONDS

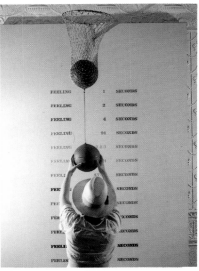

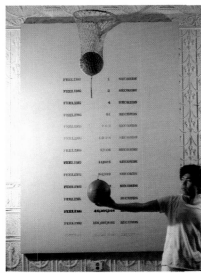

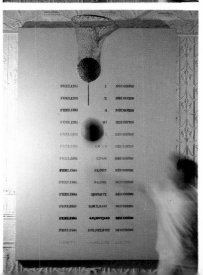

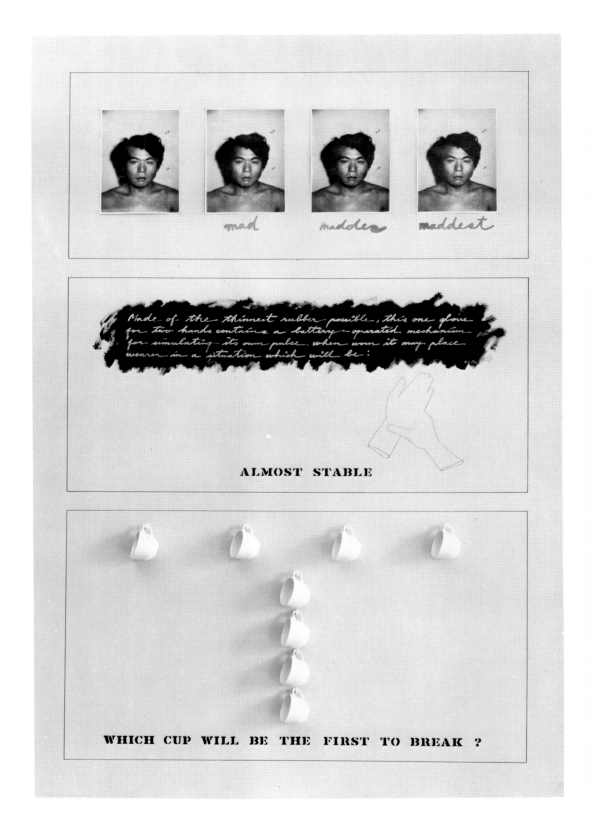

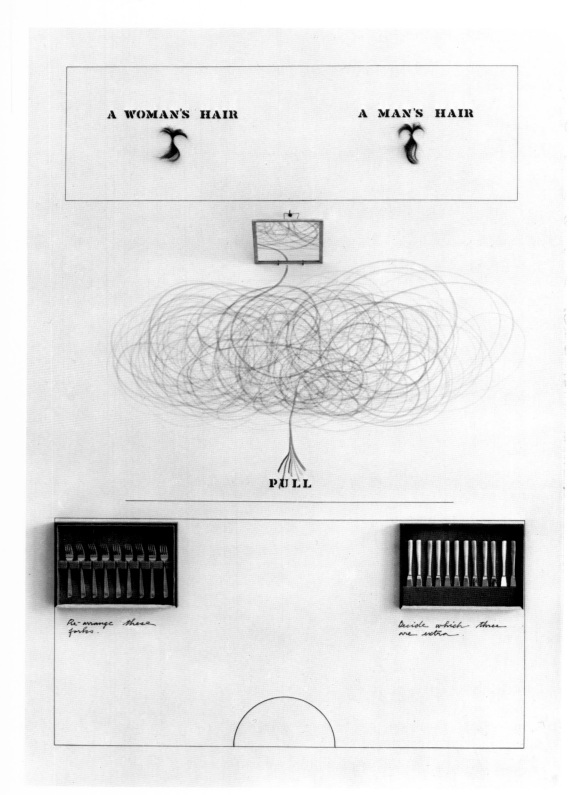

Jonathan Swift, himself the author of an important essay on feeling of meaning (i.e. *A Tritical Essay Upon the Faculties of the Mind*), left behind him at his death this note, attached to a lock of his secret love Stella's hair: "only a woman's hair."

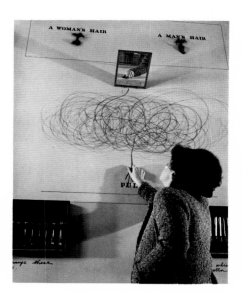

A position of believing in/
A position of believing out
from what is perceived

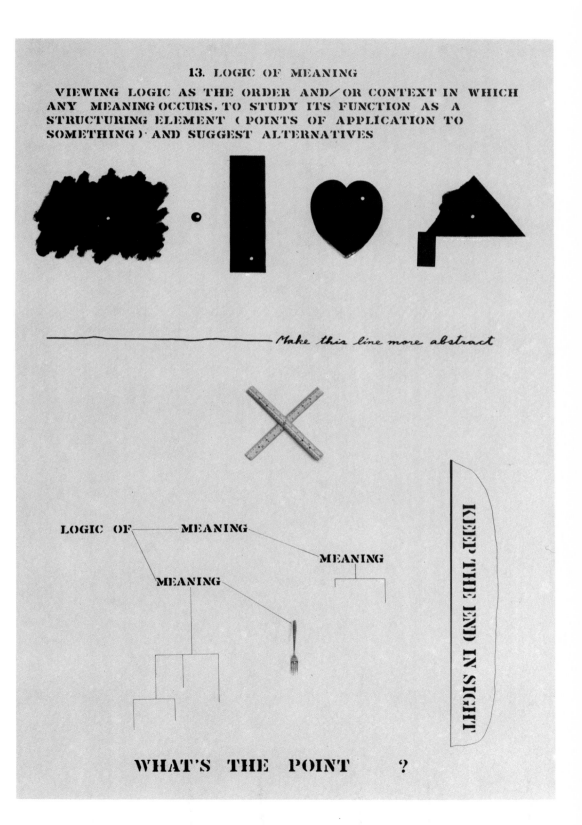

ONLY

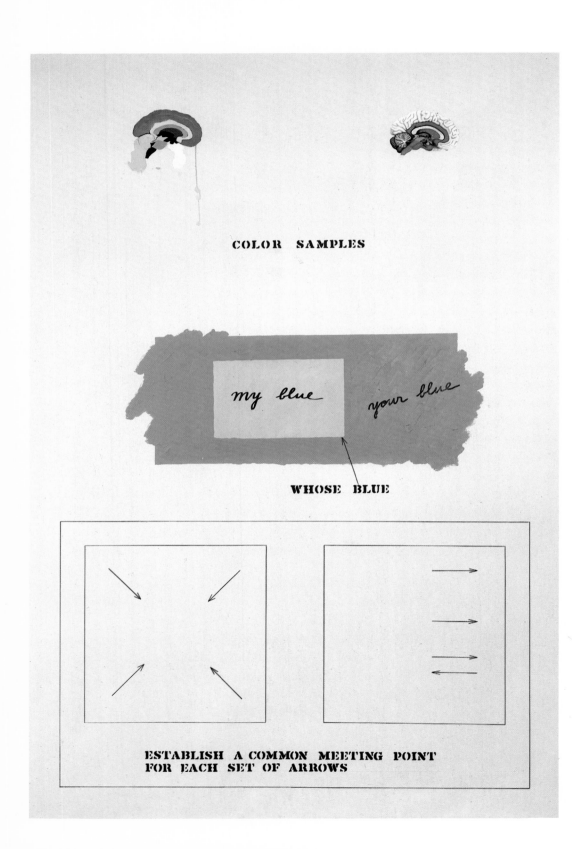

WHAT'S THE MOST LOGICAL SHAPE
FOR ANY PARTICULAR COLOR?

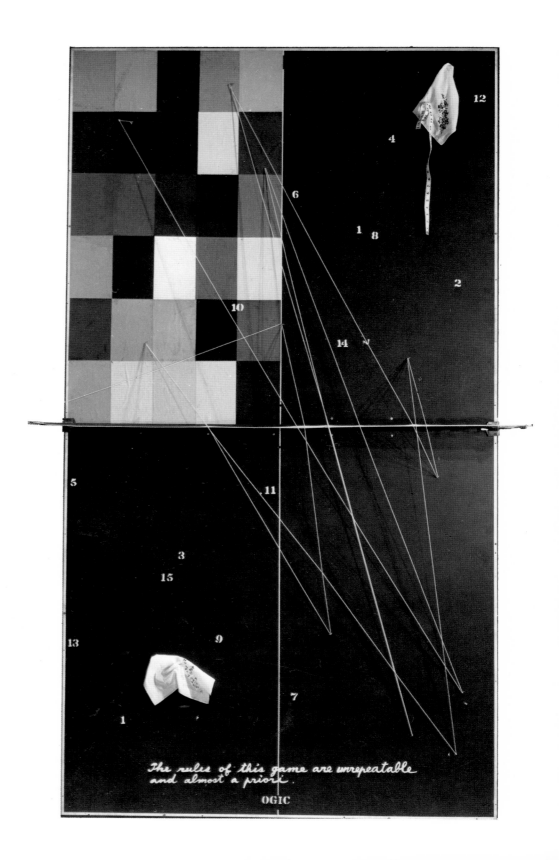

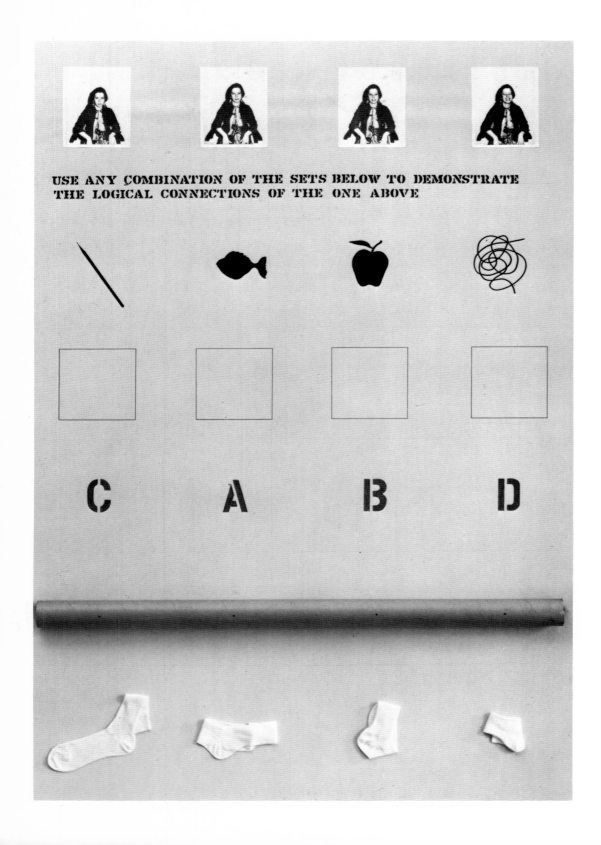

USE ANY COMBINATION OF THE SETS BELOW TO DEMONSTRATE
THE LOGICAL CONNECTIONS OF THE ONE ABOVE

C A B D

Gradients:
Inductively deductive and
Deductively induced?

January 4, 1915

Dear Mother,

It snowed all through the night. It's so difficult to recognize New York. It's all silver. This morning I went to buy bread, but it was already all sold out. Anyway, my work continues. I'm working day and night. Please don't worry about my health. My friends keep telling me what a sad time we live in. How dark this age is. I agree but I must have some hope so I cannot stop. I will not be disappointed unless I die (don't worry I don't feel that way again). Last month I began the most complicated section of the project. I am determined to find out how (if not why) our brain functions. Hundreds of people have tried before but.... Thank you for the pillows. They smell wonderful. I have to go to sleep now. I will write again soon. Will you write soon? Please take care.

Love,

Arakawa

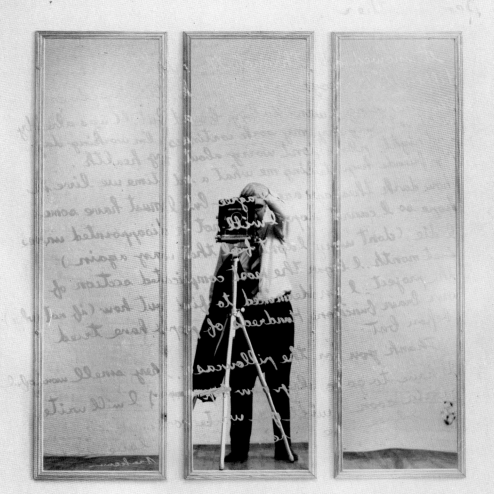

14 CONSTRUCTION OF THE MEMORY OF MEANING

A STUDY OF MEMORY: ITS OPERATIONS, ITS SCOPE, ITS ROLE IN THE REALIZATION OF MEANING. TOWARD THE CONSTRUCTION OF A TOTAL SITUATION IN WHICH MEMORY CAN REMEMBER ITSELF (ITS OWN OPERATIONS)

NIGHT

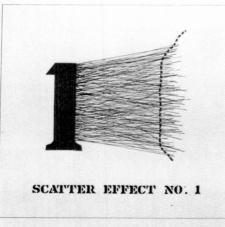

SCATTER EFFECT NO. 1

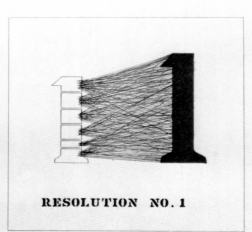

RESOLUTION NO. 1

QUARTER OF A SECOND
HALF A SECOND
ONE SECOND
TWO SECONDS
FIVE SECONDS
THIRTY SECONDS
FORTY-FIVE SECONDS
ONE MINUTE

ONE DAY
ONE WEEK
A FORTNIGHT
ONE MONTH
ONE YEAR
ONE DECADE
HALF A CENTURY
ONE CENTURY

**INDICATION OF DURATION IN PRESENT
TIME FOR MEMORIES OF PAST PERIODS**

ONE DAY
ONE WEEK
A FORTNIGHT
ONE MONTH
ONE YEAR
ONE DECADE
HALF A CENTURY
ONE CENTURY

BLUE INTO THE PAST (OUT OF THE BLUE)

QUARTER OF A SECOND
HALF A SECOND
ONE SECOND
TWO SECONDS
FIVE SECONDS
THIRTY SECONDS
FORTY-FIVE SECONDS
ONE MINUTE

DURATION IN PRESENT TIME
FOR MEMORIES OF BLUE

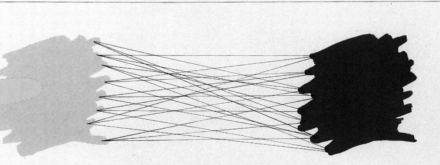

BLUE INTO BLUE. PRESENT INTO PAST.
RELATION OF REMEMBERING TO MEMORY.

ANOTHER ANGLE. SYNOPSIS

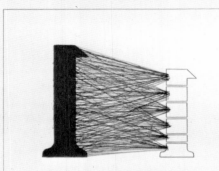

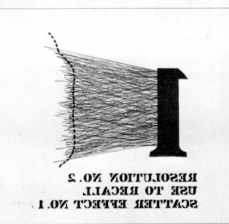

SCATTER EFFECT NO. 2
USE TO RECALL
RESOLUTION NO. 1

RESOLUTION NO. 2
USE TO RECALL
SCATTER EFFECT NO. 1

Left side continues to represent the act of remembering and the present while right side pertains to memory and the relative past.

ONE DAY — QUARTER OF A SECOND
ONE WEEK — HALF A SECOND
A FORTNIGHT — ONE SECOND
ONE MONTH — TWO SECONDS
ONE YEAR — FIVE SECONDS
ONE DECADE — THIRTY SECONDS
HALF A CENTURY — FORTY-FIVE SECONDS
ONE CENTURY — ONE MINUTE

PAST NOW PRESENT REMEMBERING
MEMORY OF PRESENT NOW PAST

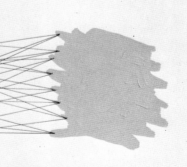

ONE DAY
ONE WEEK
A FORTNIGHT
ONE MONTH
ONE YEAR
ONE DECADE
HALF A CENTURY
ONE CENTURY

REMEMBERING OUT OF THE BLUE AS INTO THE BLUE

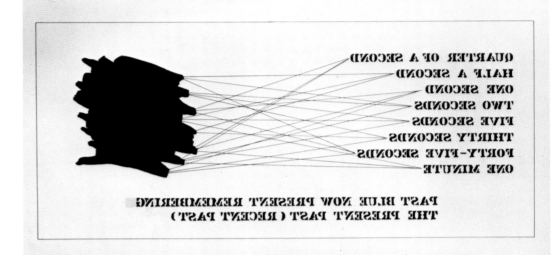

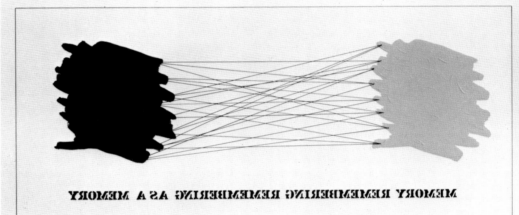

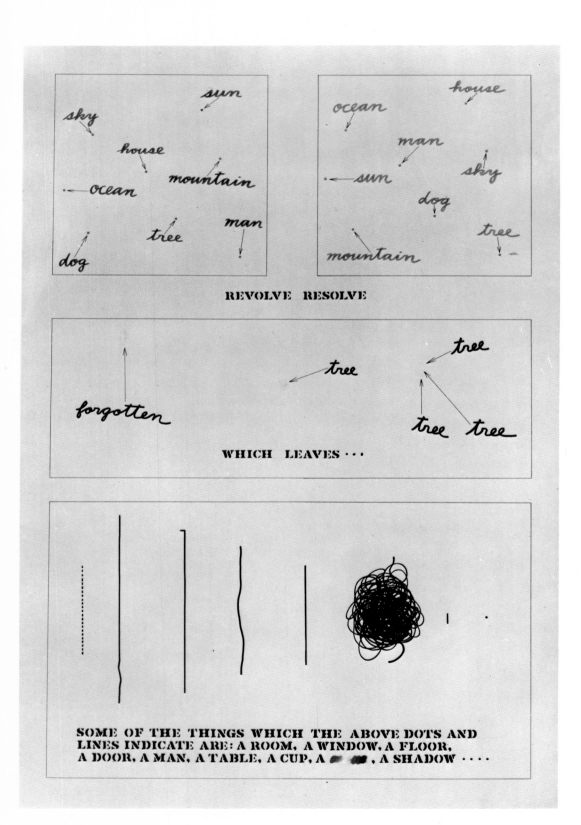

REVOLVE RESOLVE

WHICH LEAVES · · ·

SOME OF THE THINGS WHICH THE ABOVE DOTS AND
LINES INDICATE ARE: A ROOM, A WINDOW, A FLOOR,
A DOOR, A MAN, A TABLE, A CUP, A �&◾ , A SHADOW · · · ·

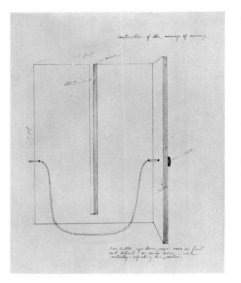

(The) The obverse

surfacing

15 MEANING OF INTELLIGENCE

AN EXPLORATION OF WHAT IS MEANT BY THE STATEMENT
OF AN INTELLIGENCE, OF WHAT TWO OR MORE ELEMENTS
(ACTIVITIES?) ARE ALIGNED WHEN SOME X IS DECLARED
INTELLIGIBLE AND OF THE POSSIBLE (IMPOSSIBLE) REASONS
BEHIND(IN FRONT OF?) THIS.

AN AREA OF INTELLIGENCE
(RIGHT AND WRONG)

AN AREA OF INTELLIGENCE
(WRONG AND RIGHT)

FIND THE LIMIT OF ERROR

THE *is to* _____ *as* OF *is to* _____

() FIRST SIGN OF SAPIENCE (ON REFLECTION)

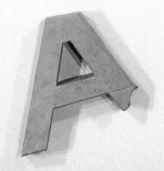

USE TWO OR THREE DIFFERENT WAYS

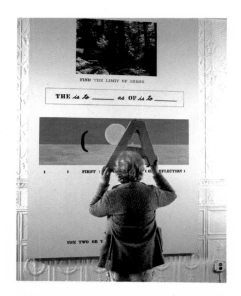

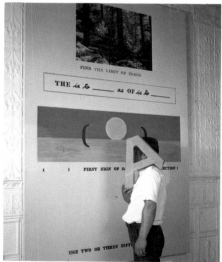

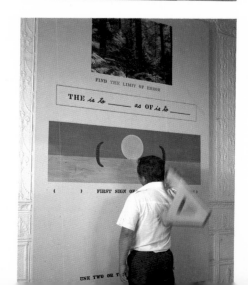

Intermittently disregard any time not marked time.

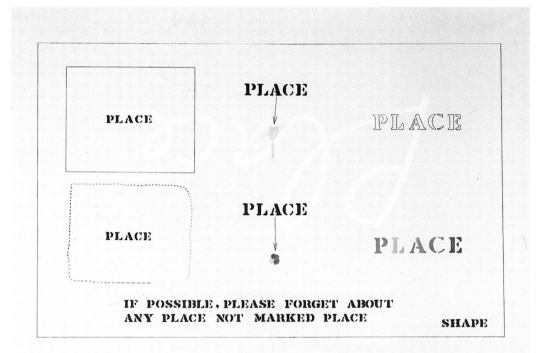

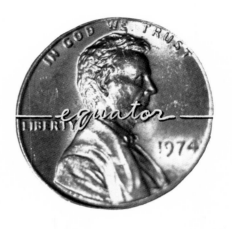

WHAT IS THIS ⟷ *what is this*

WHAT IS THIS ⬌ *what is this*

WHAT IS THIS ◖▬◗ *what is this*

NOOSE FOR A COCKROACH ⟶

I give up *I don't give up*

I DON'T GIVE UP

WHAT IS NOT MISSING?

PLEASE DON'T LAUGH

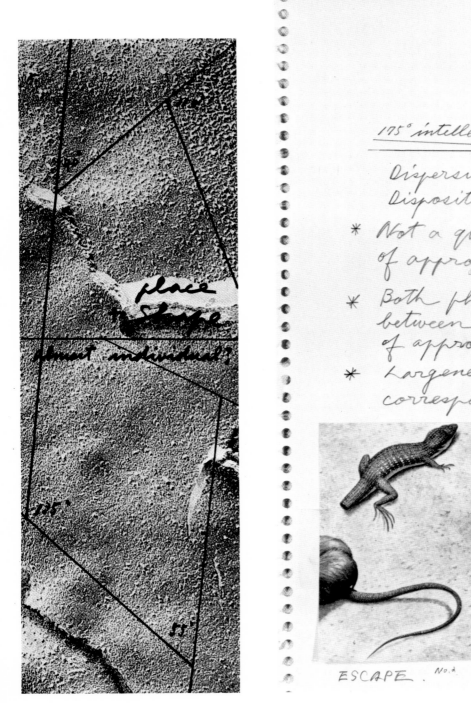

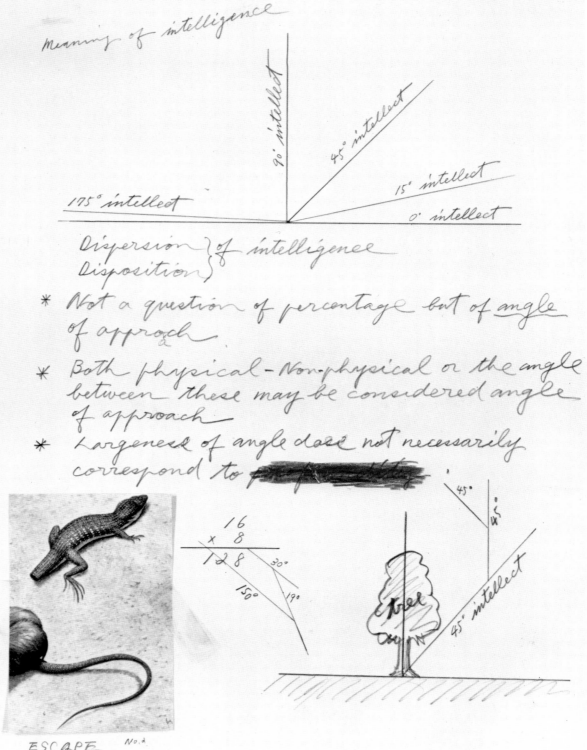

ESCAPE. No.2

16 REVIEW AND SELF-CRITICISM

REVIEW AND SELF-CRITICISM

OR

TO DEVELOP A MODEL OF THOUGHT

REVIEW AND SELF-CRITICISM

OR

TO CONSTRUCT A MODEL OF AN "I"

REVIEW AND SELF-CRITICISM

OR

TO SCULPT A MODEL OF MIND

REVIEW AND SELF-CRITICISM

OR

TO MAKE A MODEL OF BODY

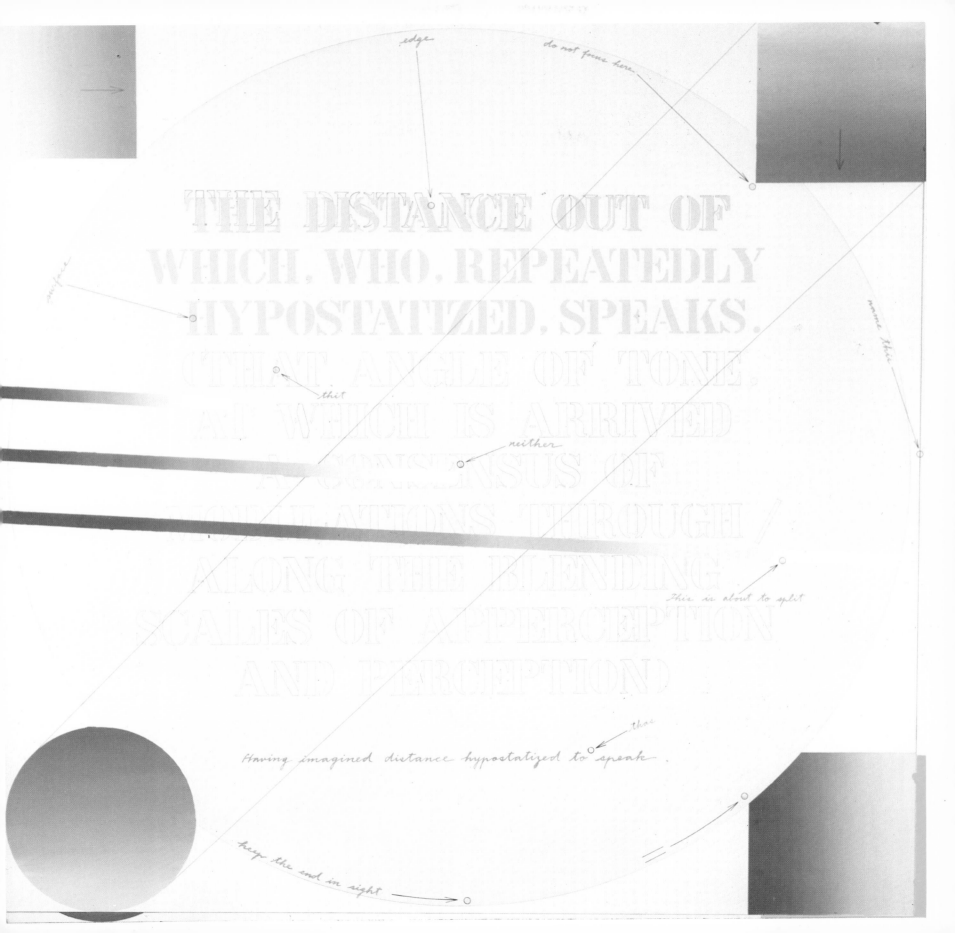

THE DISTANCE OUT OF
WHICH, WHO, REPEATEDLY
HYPOSTATIZED, SPEAKS.
(THAT ANGLE OF TONE,
AT WHICH IS ARRIVED
A CONSENSUS OF
MODULATIONS THROUGH /
ALONG THE BLENDING
SCALES OF APPERCEPTION
AND PERCEPTION)

edge

do not focus here

surface

this

neither

name this

This is about to split

thus

Having imagined distance hypostatized to speak.

keep the end in sight

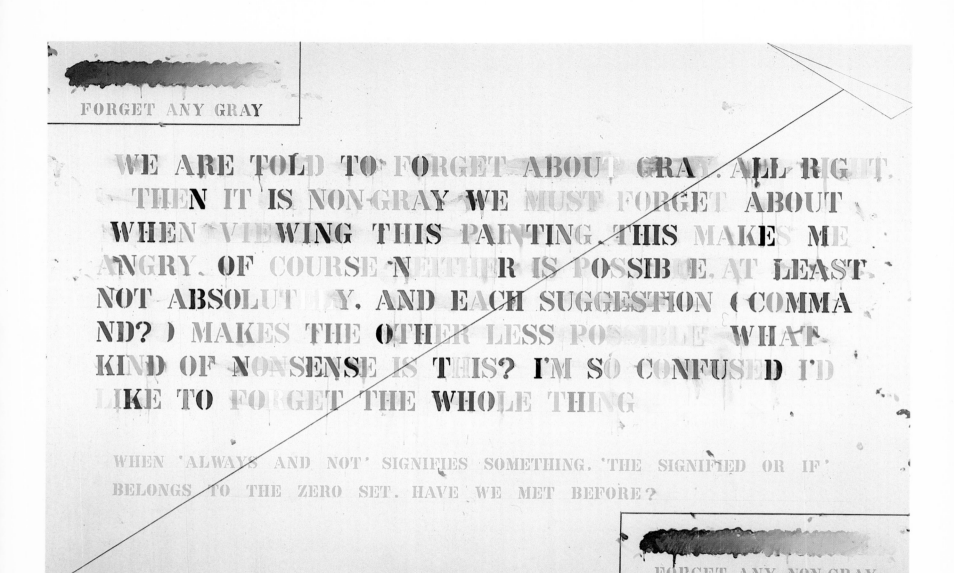

FORGET ANY GRAY

WE ARE TOLD TO FORGET ABOUT GRAY. ALL RIGHT.
THEN IT IS NON-GRAY WE MUST FORGET ABOUT
WHEN VIEWING THIS PAINTING. THIS MAKES ME
ANGRY. OF COURSE NEITHER IS POSSIBLE. AT LEAST
NOT ABSOLUTELY. AND EACH SUGGESTION (COMMA
ND?) MAKES THE OTHER LESS POSSIBLE. WHAT
KIND OF NONSENSE IS THIS? I'M SO CONFUSED I'D
LIKE TO FORGET THE WHOLE THING

WHEN 'ALWAYS AND NOT' SIGNIFIES SOMETHING. 'THE SIGNIFIED OR IF'
BELONGS TO THE ZERO SET. HAVE WE MET BEFORE?

FORGET ANY NON-GRAY

A condition of suspended confusion through which
"I" may shift under observation. Or a means for
viewing thoughts which might pass between "I" and
"me". So, from irregular or parallel intentions,
something slowly is forming....

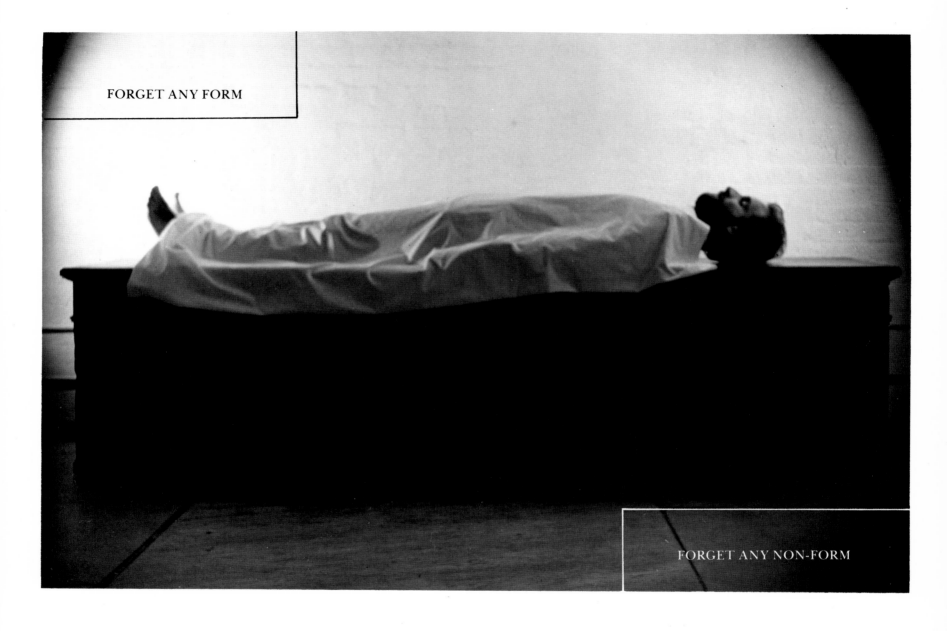

FORGET ANY FORM

FORGET ANY NON-FORM

WE ARE TOLD TO FORGET ANY FORM.
ALL RIGHT. THEN IT IS NON-FORM WE MUST
FORGET ABOUT WHEN VIEWING THIS
PHOTOGRAPH. THIS BRINGS CONFUSION.
OF COURSE, NEITHER IS POSSIBLE, AT LEAST
NOT ABSOLUTELY, AND EACH SUGGESTION
(COMMAND?) MAKES THE OTHER LESS
POSSIBLE. WHAT KIND OF NONSENSE IS
THIS? THROUGH A DOUBLE SUPPRESSION
IS IT THAT "I" MAY BRING MATTER INTO
THOUGHT?

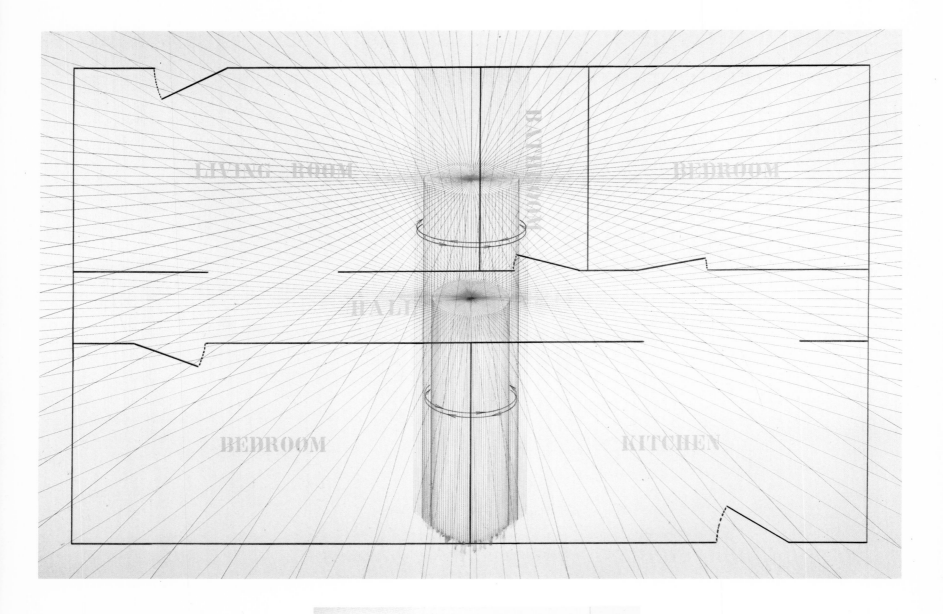

THE GIVEN DESCRIBES LANGUAGES TRAIN
ING! TO WHAT EXTENT? FOR EXAMPLE, WHAT
IS THE RELATION OF THE GIVEN TO THE ACQUIRED
REGARDING PERCEPTION? WHEN IN TURN LANGUAGE
S ARE USED TO DESCRIBE THE GIVEN OR ANY OF
ITS ASPECTS. IT SEEMS THAT THE MECHANISM(PROCES
S) OF MEANING OCCURS. BUT TO WHAT EXTENT? CAN
CONSCIOUSNESS SUPERSEDE ITS OWN MECHANISM
(PROCESS) OF FOCUSING? IF NOT HOW MUCH OF WHAT
SEEMS TO OCCUR IS NONSENSE?

SHAPE IS USED TO PLOT SENSE COLOR TO RELATE QUALITY OF
NONSENSE A SIMILAR PAIRING MIGHT BE FOUND IN ANY LIVING ROOM

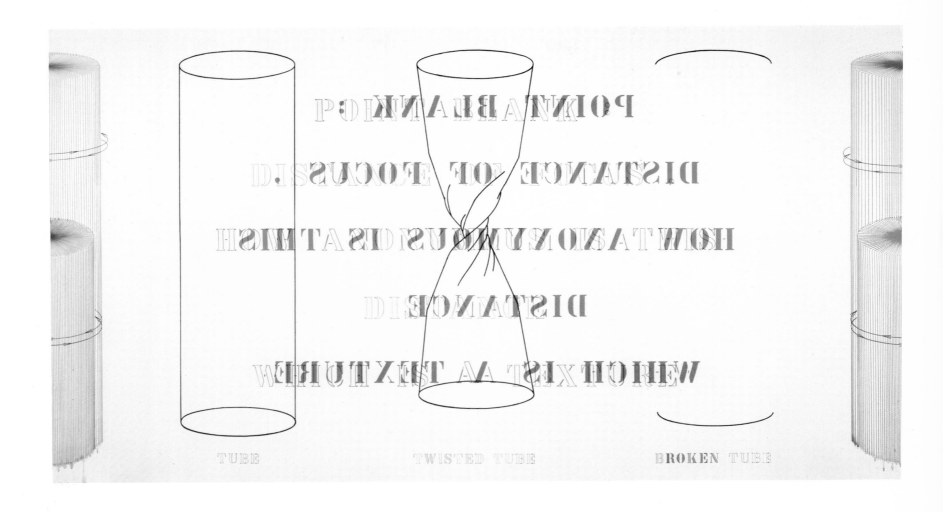

TUBE TWISTED TUBE BROKEN TUBE

PASSAGES THROUGH WHICH THE
THOUGHT OF SUPERSEDING A FOCUS MIGHT
MOVE. THESE SUCKING PASSAGES
(OMNI-DIRECTIONAL) OF THE TEXTURE OF
IMAGINATION ARE BOTH COMPONENTS AND
INDICATORS OF WHAT SUCH A THOUGHT
MIGHT BE.

TO CLEAVE

TWO OR THREE POINTS OF DEPARTURE

EDGE BLANK

RECEIVABILITY

BY

SATURATION VECTORS

LAYERED APPROXIMATIONS

PARALLEL DRIFT

ANGULAR SPIN

PRE-HOLE

AS IF BROKEN TUBES

WITHIN BUT BETWEEN THE NUMBERS BEING COUNTED

BROKEN RAIL

SUCKING PASSAGE (OMNI-DIRECTIONAL)

RANDOM, PARTIAL SHRINKING

PROFILE JUNCTURE

LINEAR BURPS

A SPEED OF SHIFTING

CORE OF FLEXIBILITY ONLY

DIFFUSE RECEDING

WAITING TEXTURE

IMPRESSIONABLE STRETCHING

REFLECTION

DEFLECTION

INFLECTION

SOUND JOINT

MOUNTING

PUSH OF BLANK (INSTANT GROUP)

CONSTANT VERBAL QUIVERINGS

BY THE END IN SIGHT

OUT OF THE BLUE "TO" AND "FROM"

SUDDEN DROP

SCALE OF ACTION

CALL OF CONTINUITY

Where edge blank eddies
 The texture of receivability

By

Vectors may saturate
 Pieces of layered approximations received

The surfacing of a parallel drift
 generating a sense of out and in,
 angular spin, the depth-maker of a surface

Distance of time, pre-hole.
 Tunneling volumes of degrees as if
 broken tubes

 Within but between the numbers being counted

 The setting of a broken rail
 The enormous moveability of a sucking passage (omni-directional)
 random, partial shrinking

 Appearance of some profile junctures, some linear burps
 Many

 Volumes exchanged, a speed of shifting

 Place for construction of a core of flexibility only

 Diffuse receding which parallels and contours
 waiting texture

 The unique range of elasticities of
 impressionable stretching, not yet texture

 The regulating of reflection, deflection, inflection

 Coalescence of sound joints, guides

 Realization of mounting and push of duration (instant group)

 Both senders and receivers, configurational coverings on
 all and any scale

 Pull of breath

 To keep the end in sight; balance

 As always the necessity of out of the blue, "to" and "from"

 A sudden drop into a scale of action

 The call of continuity.

MAKER, BETWEEN ABOVE AND BELOW

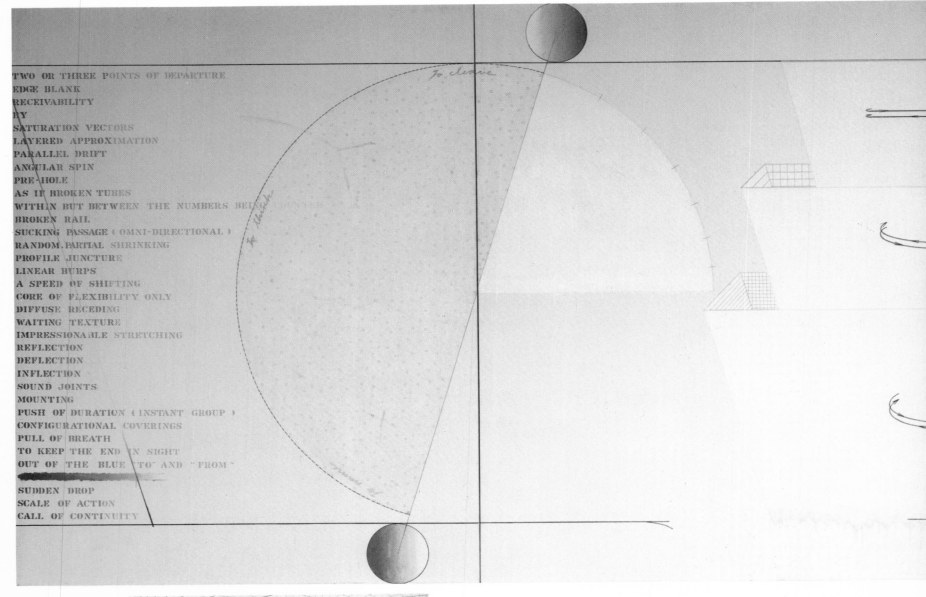

TWO OR THREE POINTS OF DEPARTURE
EDGE BLANK
RECEIVABILITY
BY
SATURATION VECTORS
LAYERED APPROXIMATION
PARALLEL DRIFT
ANGULAR SPIN
PRE-HOLE
AS IF BROKEN TUBES
WITHIN BUT BETWEEN THE NUMBERS BEING COUNTED
BROKEN RAIL
SUCKING PASSAGE (OMNI-DIRECTIONAL)
RANDOM, PARTIAL SHRINKING
PROFILE JUNCTURE
LINEAR BURPS
A SPEED OF SHIFTING
CORE OF FLEXIBILITY ONLY
DIFFUSE RECEDING
WAITING TEXTURE
IMPRESSIONABLE STRETCHING
REFLECTION
DEFLECTION
INFLECTION
SOUND JOINTS
MOUNTING
PUSH OF DURATION (INSTANT GROUP)
CONFIGURATIONAL COVERINGS
PULL OF BREATH
TO KEEP THE END IN SIGHT
OUT OF THE BLUE "TO" AND "FROM"

SUDDEN DROP
SCALE OF ACTION
CALL OF CONTINUITY

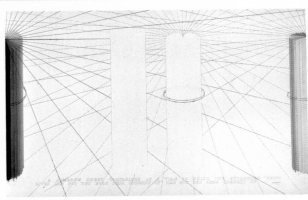

BLANK MODEL/MODEL BLANK

POINT-BLANK: SPACE OF
FOCUS, VOLUME, WHAT SHAPE(S)
IS THIS FORMING DISTANCE
WHICH IS A SIZELESS AND/OR
SPORADIC TEXTURE?

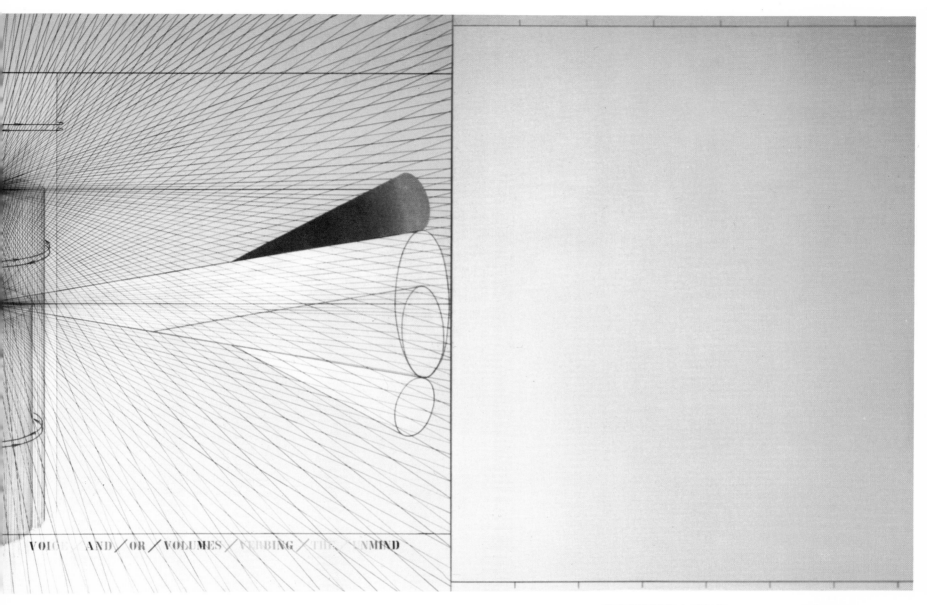

VOICE / AND / OR / VOLUMES / VERBING / THE / MIND

DOUBLE POINT-BLANK: FOCUS AS
DISTANCE, SURFACE, HOW REMEMBERED
IS THIS FORMING DISTANCE WHICH
MAKES A TEXTURE OF TIME?

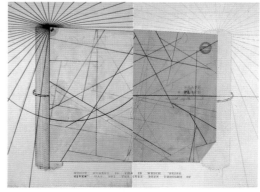

GASP OF CONTINUITY

Two or three points of departure.

Top view β

Two or three points

The setting of a broken nail
The enormous movability of a
sustaining passage (omni-directional)
random partial shrinking

White edge blank edise
The texture of receivability

x Diffuse receding which parallels and contours
——— waiting texture (▬ everywhere)

Volumes exchanged

pull of breath

The call of continuity

by

sudden drop into
a scale of action

place for contraction of
one of plasticity only

As always the necessity of
out of the blue "to" and "from"

Distance of time pre-hole
funneling volumes of degree
as if broken tubes

by

Top view θ

Within but between the number

x Sizeless yet all the same size (place) both senders and receivers, co

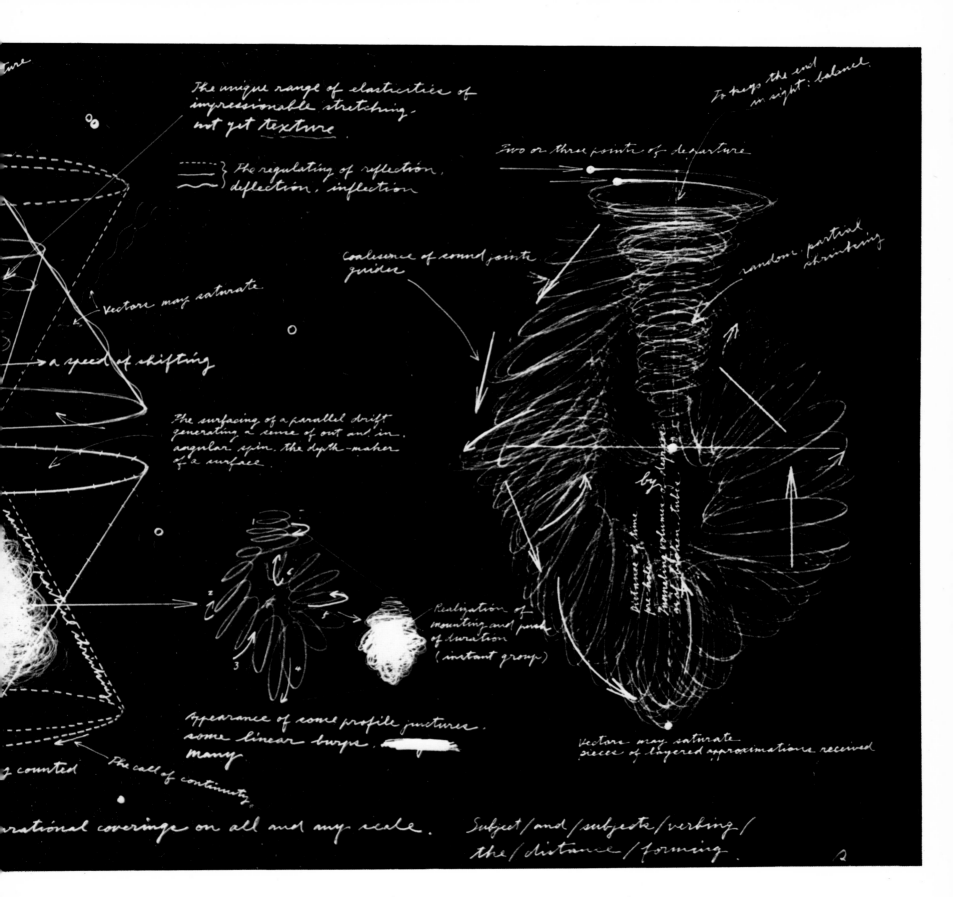

First stage of the construction of the poem on page 95.